Child Photography

Child Photography

BY ALLYN SALOMON
With Photographs by Elyse Lewin

AMPHOTO
American Photographic Book Publishing
An Imprint of Watson-Guptill Publications
New York, New York

All photographs for which no other credit is given are by Elyse Lewin.

Copyright © 1981 by American Photographic Book Publishing.

Photographs copyright © 1981 by Elyse Lewin.

First published in New York, New York, by American Photographic
Book Publishing: an imprint of Watson-Guptill Publications, a
division of Billboard Publications, Inc., 1515 Broadway, New York,
NY 10036.

Library of Congress Cataloging in Publication Data
Salomon, Allyn.
 Child photography.
 Includes index.
 1. Photography of children. I. Lewin, Elyse.
II. Title.
TR575.S24 778.9'25 81-10958
ISBN 0-8174-3665-0 AACR2

Manufactured in the United States of America

First Printing, 1981

1 2 3 4 5 6 7 8 9/86 85 84 83 82 81

To all of those who are lucky enough to
see their intentions take form—whether
as children, photographs, or otherwise.

A. S.

I'd like to dedicate this book to my
three children, Cheryl, Lian, and Jim,
whose adorable faces made me famous.
And to my husband, Lester Wertheimer,
who has always been encouraging.

E. L.

Contents

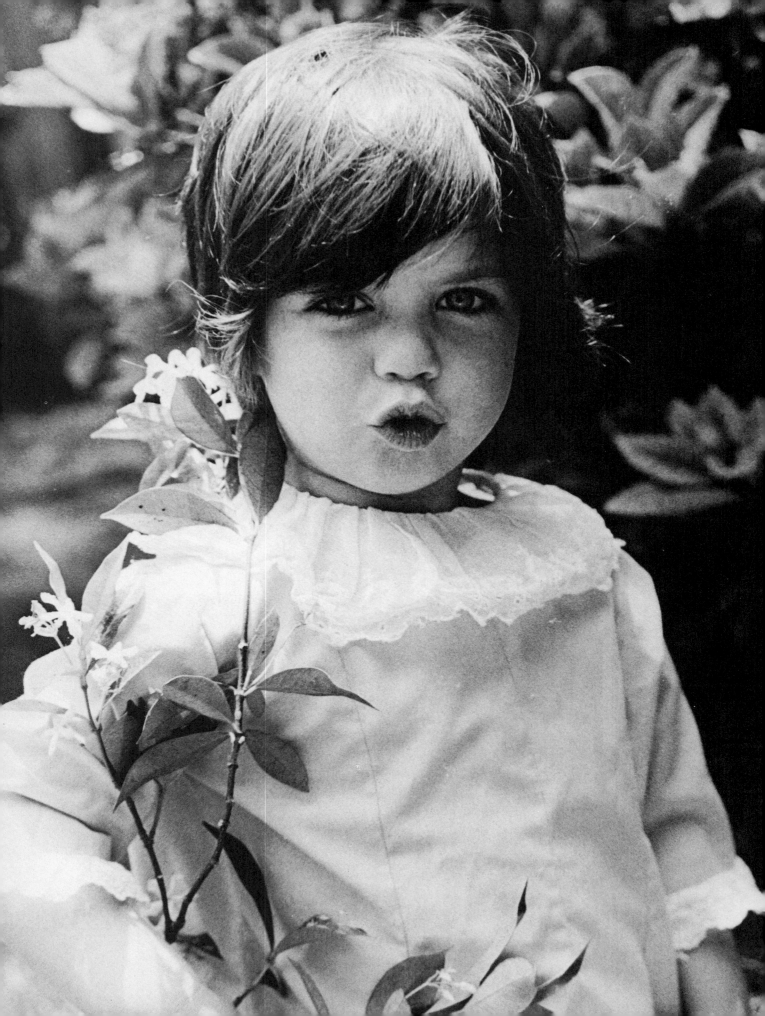

CHAPTER ONE

Introduction: Focus on the Profession

NYONE WHO hates children and dogs can't be all bad," W.C. Fields once said . . . and, it's fair to add, also can't hope to succeed as a professional child photographer.

Not that you have to love children in order to photograph them in a way that's fresh, attractive and commercially appealing. But you do have to like them, respect them and respond to them in a way that allows you to evoke and capture the unique essence and charm of each child. Most of all, you have to understand what makes children tick.

And that, in a nutshell, is the prime requisite for success as a professional child photographer. So, it should come as no surprise that in a profession generally dominated by males, this is one specialty that's as open to women as to men. Sexist as it may sound, the pragmatic fact is that children, young children especially, tend to be more relaxed, easy and less self-conscious with women than with men: women are as familiar to them as their bedroom wallpaper. And the reverse is true, too. Whether it's a result of biology or cultural orientation or experience, many women do have a "feel" for what sparks and motivates youngsters, and that constitutes a significant head start toward success in this lucrative specialty.

Of course, the professional child photographer needs some other things, too. You need reliable cameras and lighting equipment, for example, and enough experience to use them competently; but the typical "advanced amateur" already has these. You also have to know how to adapt and refine your equipment, your shooting ability and your "feel" for children into smoothly choreographed professional procedures that work every time; but the techniques for doing that are, as you'll see in this book, not hard to learn. What you don't necessarily need is a full-scale studio, especially at first. Child photography as a commercial endeavor is one in which you can make a solid professional start working part-time from your home.

And once you do get a foothold—and work hard to make the most of it—the specialty can offer extraordinary rewards in prestige, satisfaction and money. The markets for photos of children are rich and varied. For most beginners the easiest entry is to do work for private clients: every parent is a potential customer. This

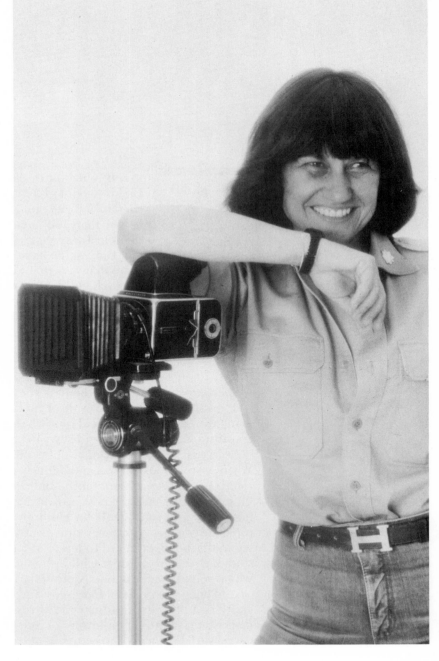

can be a lucrative end in itself or a springboard to editorial assignments and advertising work. At the very height of the craft, where you work on assignment for top editors and advertisers, it's not unreasonable to expect a six-digit annual income.

INTRODUCING ELYSE LEWIN

A case in point is Elyse Lewin, the dynamic and enormously successful photographer who provided all the illustrations and much of the source material for this book. Her work has been featured in *Cosmopolitan, Glamour, House Beautiful, Modern Bride, Oui,* and many other top-drawer publications in the U.S.A. and abroad, and her list of commercial accounts reads like a Who's Who entry in Family Advertising: from Sears to Johnson & Johnson, Gerber's to Mattel Toys. Yet she made the transition from rank amateur to World Class professional in less than a decade, without any formal training— and almost by accident.

Lewin was born in Manila, the granddaughter of an American who had settled in the Philippines in the early 1900s. She spent her childhood in the chaos and terror of World War II.

"During the Japanese occupation," she recalls, "We were surrounded by soldiers, street fighting, death. Once a shell blew out the second story of our house. My sister and I spent hours in bomb shelters, playing out fantasy lives with our dolls. Later, as a photographer, I tried to recreate that dream world, with little girls in long white nightgowns pretending to be safe and secure, surrounded by tenderness and peace."

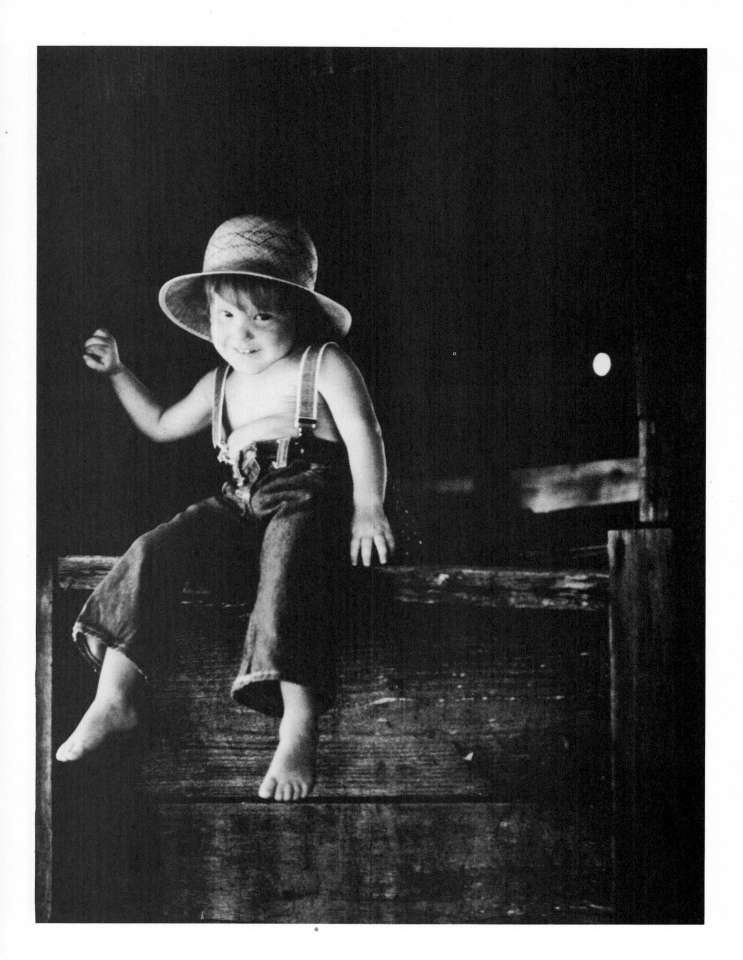

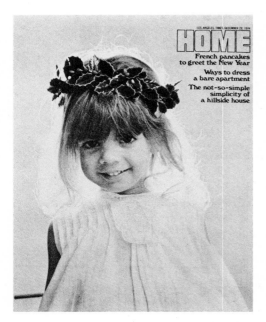

LOS ANGELES TIMES, DECEMBER 22, 1974

HOME

French pancakes
to greet the New Year

Ways to dress
a bare apartment

The not-so-simple
simplicity of
a hillside house

After the war Lewin's family moved to Los Angeles, and she slid into another fantasy: "Growing up, I saw myself becoming Brenda Starr, girl reporter. . . . gorgeous and efficient, always off on an exciting assignment in some romantic part of the world."

It didn't work out that way; at least, not immediately. Lewin married, had children, and settled down into housewifery. And like many a typical mother, she began taking pictures of her children.

With not-too-typical results. One day when she took some of her photos to a local camera shop for processing, the dealer said, "These are terrific. Can we make enlargements and put them in the window?"

For a woman with her drive, that was a clear signal and a trigger. After sharpening her technique using her own children (willing or not) as subjects, she began photographing neighbors' kids for a fee. Next she quickly developed marketing and promotion strategies that allowed her to increase her income from each customer.

"Right around that time," she says, "Paul Ulmer, the legendary chief of *Life* magazine's darkroom, let me hang out at the local office where film was processed. I began to learn how the best photographers composed and lighted their shots."

It wasn't long before Lewin sold her first color cover to *Home* magazine, a Sunday section of the *Los Angeles Times*. Other editorial assignments followed, and her circle of private clients grew larger and richer. Before she made her almost total switch to editorial and advertising photography, her

Left. The Lewin wit at work—rakish angle of the wreath that would catch the eye of any editor.

Right. The ability to make an infant respond naturally but on cue is essential for a commercial children's photographer.

This little doggie may change your ideas about baby toys forever.

The appearance and attitudes of models should match product concept. Playful poses go with play clothes in this fashion layout.

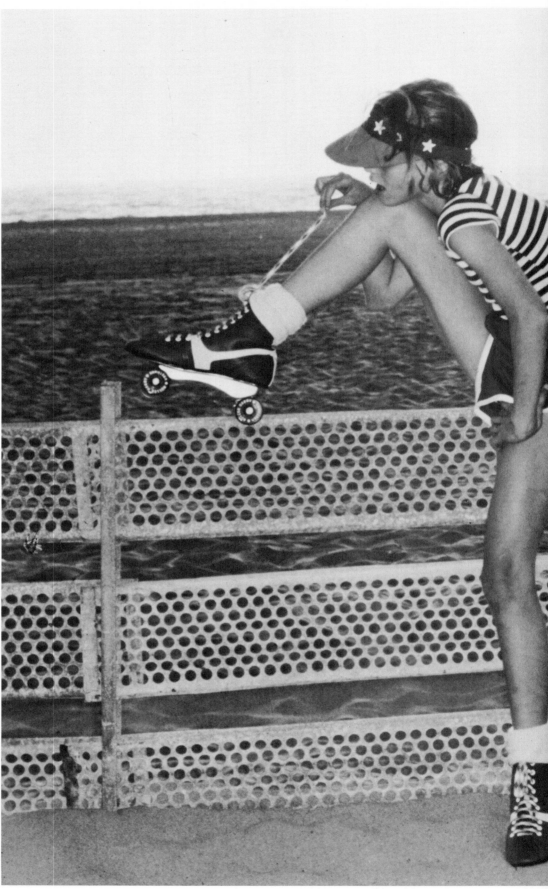

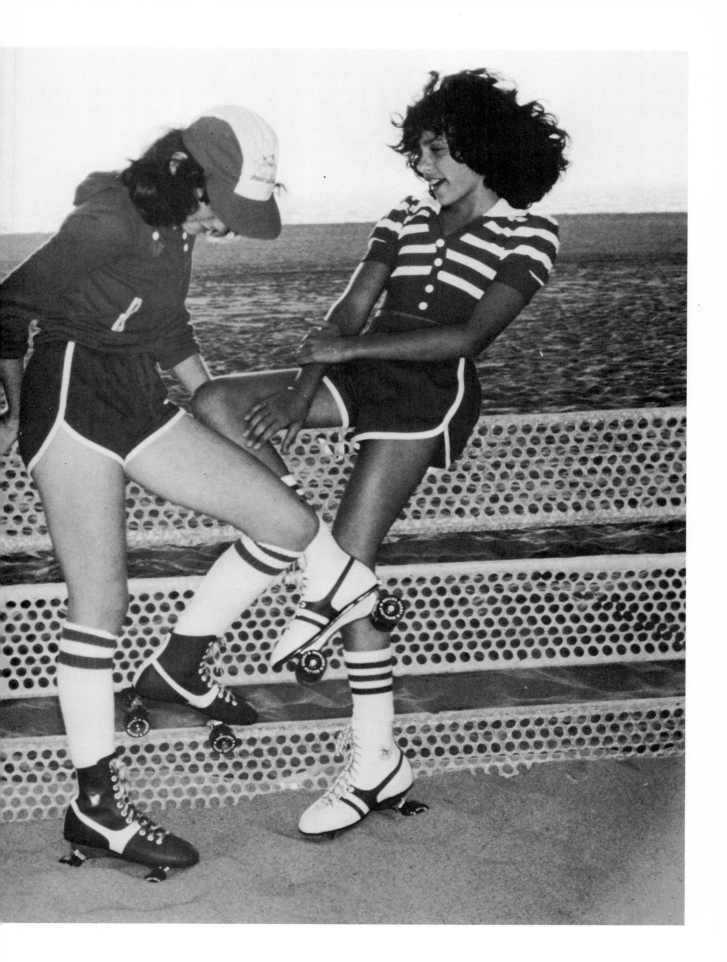

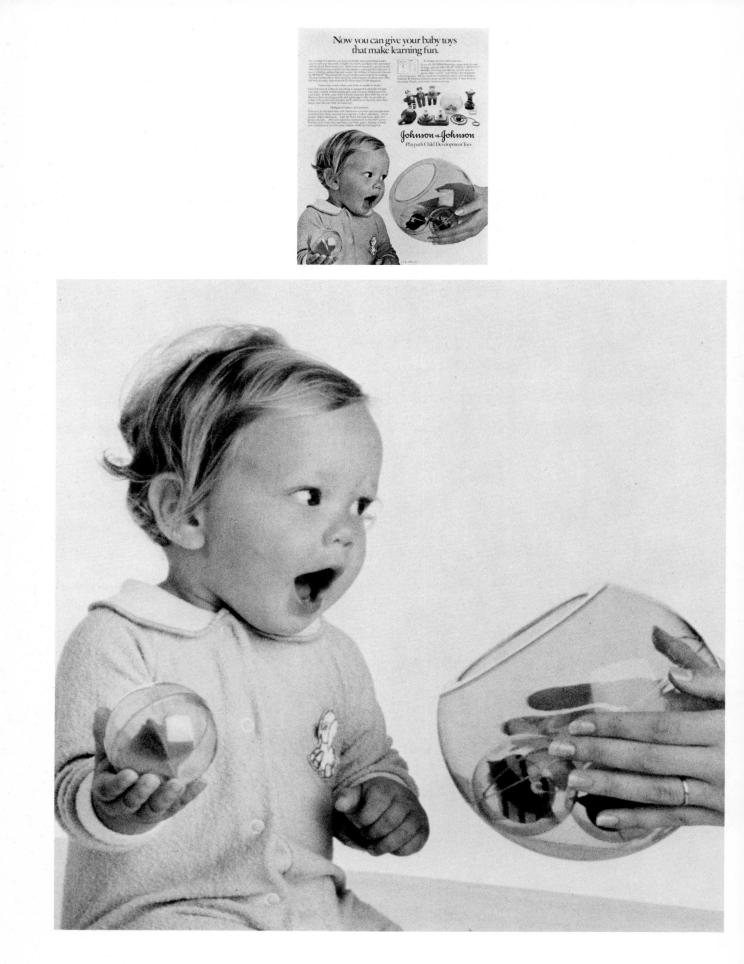

private clients were paying as much as $500 a child for a shooting.

Throughout this period Lewin was still working out of her home. She did all her shooting for private clients "on location"—at or around the client's home or at a nearby park or playground, in the child's own territory. This approach made a studio unnecessary for portrait work, and the use of a home office as headquarters was adequate for editorial assignments, too.

But as she began to acquire commercial clients, it wasn't enough. "Commercial work calls for models and sets and lots of equipment, and for very controlled conditions," she says. "I began to spend a lot of time just arranging to rent studio space, and setting it up properly. As my work became more and more advertiser oriented, it was time for my own studio."

About five years into her career, Lewin and her husband, architect Lester Wertheimer, made that final commitment. They bought an affordable chunk of land on a busy street in west Hollywood, and built an office and studio large enough to accommodate both her assistants and her full-time sales representative. Most important, the white, bright studio itself is shrewdly designed and equipped to meet all the needs of commercial clients—and of children.

Although Lewin's work today by no means excludes adult models, products, and fashions, she is still best-known and most sought-after for her expressive, poignant, sometimes sentimental, often witty, and always charming and spontaneous-looking pictures of children. As they say in editorial and advertising offices from coast to coast, "Nobody does kids like Elyse."

"I've always been good with children," she says. "Maybe that's because I feel I've never seen an ugly child. I find all of them remarkable, unique, fascinating. There's magic in each child. The whole trick in child photography is to find that magic, stimulate it, bring it out. And then capture it on film."

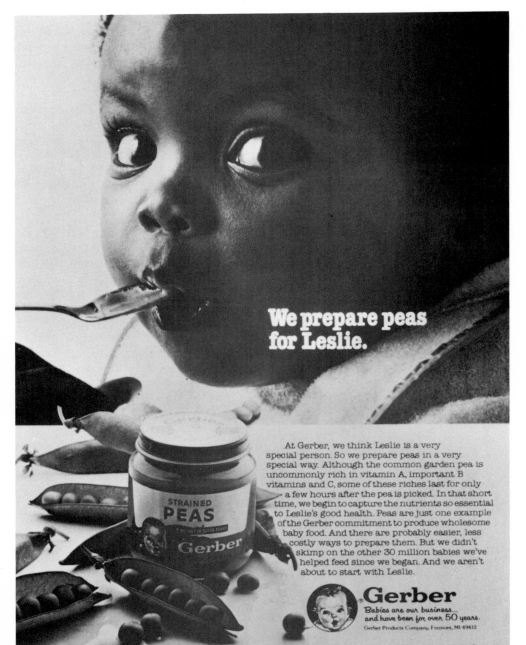

We prepare peas for Leslie.

At Gerber, we think Leslie is a very special person. So we prepare peas in a very special way. Although the common garden pea is uncommonly rich in vitamin A, important B vitamins and C, some of these riches last for only a few hours after the pea is picked. In that short time, we begin to capture the nutrients so essential to Leslie's good health. Peas are just one example of the Gerber commitment to produce wholesome baby food. And there are probably easier, less costly ways to prepare them. But we didn't skimp on the other 30 million babies we've helped feed since we began. And we aren't about to start with Leslie.

Gerber
Babies are our business...
and have been for over 50 years.
Gerber Products Company, Fremont, MI 49412

We know a lot about food because we care a lot about babies.

We prepare peas for Jamie.

At Gerber, we think Jamie is a very special person. So we prepare peas in a very special way. Although the common garden pea is uncommonly rich in vitamin A, important B vitamins and C, some of these riches last for only a few hours after the pea is picked. In that short time, we begin to capture the nutrients so essential to Jamie's good health. Peas are just one example of the Gerber commitment to produce wholesome baby food. And there are probably easier, less costly ways to prepare them. But we didn't skimp on the other 30 million babies we've helped feed since we began. And we aren't about to start with Jamie.

Gerber
Babies are our business...
and have been for over 50 years.
Gerber Products Company, Fremont, MI 49412

We know a lot about food because we care a lot about babies.

Homebaked cookies for Easter. Quick like a bunny. From Mrs. Goodcookie.™

No mixes to mix, no rolls to slice, no mess to clean up. You don't even have to grease a pan. Mrs. Goodcookie frozen cookie buttons go from box to cookie sheet, and in 12 minutes, hot, chewy, delicious cookies happen.

Three dozen cookies in every box. Choose from natural-flavored Chocolate Chip or Chocolate Chocolate Chip, Oatmeal Raisin, and Sugar.

There's always time for hot homebaked cookies with Mrs. Goodcookie. And they're so easy to dress up for Easter, too!

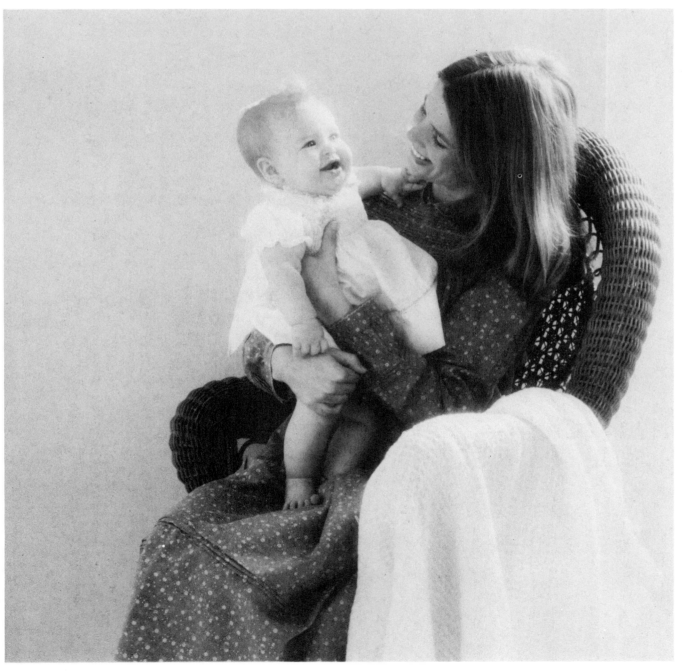

When you're 3½
and you just fell off your trike
and your mother's at the market
and the babysitter is new.
That's what Mattel's
Cuddle Loves are for.

"Saturday's child works hard for a living."

WHIPPER SNAPPERS® BY OSHKOSH B'GOSH designs the bib overall in Cone Stacord that's 84% cotton, 16% Dacron® polyester. Red, navy, beige, brown, rust, royal blue, light blue and green in children's sizes 1 to 7 and boy's 8 to 16.

Cone corduroy

Bringing out the Magic

EWIN SQUINTS into the viewfinder of her Nikon. The boy stands stiffly on the grass, a frozen smile on his nine-year-old face. He waits for the click of the shutter. And waits some more.

"Hey," he says finally, "when are you gonna take the picture?"

That's Lewin's cue. She laughs. "I can't take a picture of you with that silly smile," she says. Her speech, as always, is quick, intense, exploding with energy and enthusiasm. "C'mon, Donny, be yourself. Stick out your tongue at me."

The child looks surprised. *Click.*

He sticks out his tongue. *Click.*

"Great! Terrific, that's what we need," Lewin says. "Now wrinkle your nose." *Click.* "Cute, Donny, that's funny, now show me your back, go ahead, turn around . . ." *Click.* "Again, again." *Click.*

The child grins delightedly. *Click.* "Hey, I'm gettin' dizzy," he says, and makes an exaggerated show of teetering. *Click, click.*

Suddenly Lewin's assistant tosses Donny a basketball. The boy grabs it. *Click.* He grins gleefully at the unexpected catch. *Click.* He hugs the ball smugly. *Click.*

"Good!" says Lewin quickly. "Okay, now pretend you want to make a shot and you've got to get around a guard." *Click.* "Great, keep going, it's one-on-one and he's tough." *Click, click.* "Now, see my helper here?" *Click.* "Pass the ball to him, hard!" *Click.*

"Super ball handling," she says, "but tell me, Donny, how are you with multiplication?"

The child puts his hands on his hips and looks dismayed. *Click.* "Multiplication?" he says. *Click.*

"Sure," says Lewin. "Like, what's seven times twenty? C'mon, you can do it."

The boy frowns. *Click.* Thinks about it. *Click.* He looks triumphant as he sees an answer. *Click.*

"A hundred and forty," he calls out and laughs. *Click, click.*

Row, row, row your boat . . . When all else fails, persuade a child who's frozen by your presence to sing.

Right. Every child has a unique quality, says Lewin. The charm of this child was captured by a combination of clothing, lighting, and the photographer's alertness.

Below. To get spontaneous, natural photos, put the child into a controlled situation, make something happen, and shoot. Lewin holds a child's attention by nudging him into participation with challenges, surprises, and praise.

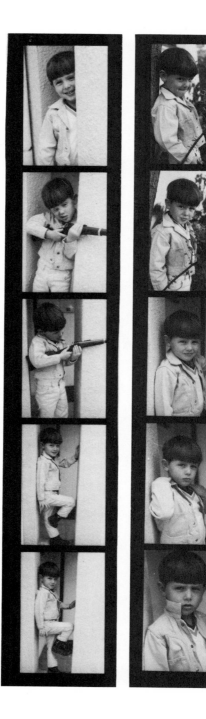

That's Lewin at work. Getting the child to lose his self-consciousness. Making him respond, react, participate. Bringing out the magic.

Faced with a camera, she points out, the average child—even some professional child models—will freeze, smile rigidly, turn into a reasonable facsimile of a plastic doll. As a photographer you have to overcome that stiffness.

How? By setting up controlled situations that will bring out and dramatize what you see as the child's personality. The best pictures happen when the child is responding in his own way: doing his or her thing, not yours. Nevertheless, the way *you* see the child is what you bring to the picture.

"If you think the child is a little devil," says Lewin, "set up situations that will show him that way. If you see him as an adorable little cupcake, show him as a cupcake. If you think he's sad, withdrawn, overwhelmed by a world that's too big for him, show him small in big, dim places, looking out at his world with solemn eyes.

"What you see as the essence of the child is your statement. And the strength of your statement is what gives the picture value."

DRAMATIZING THE ESSENCE

What you see as the child's essential character should determine what kind of situations you set up for him to respond to, your choice of background and clothing, and even your choice of equipment and shooting technique. For example:

When you see the child as active, outgoing, joyous, set up situations that allow him or her to run, move, play.

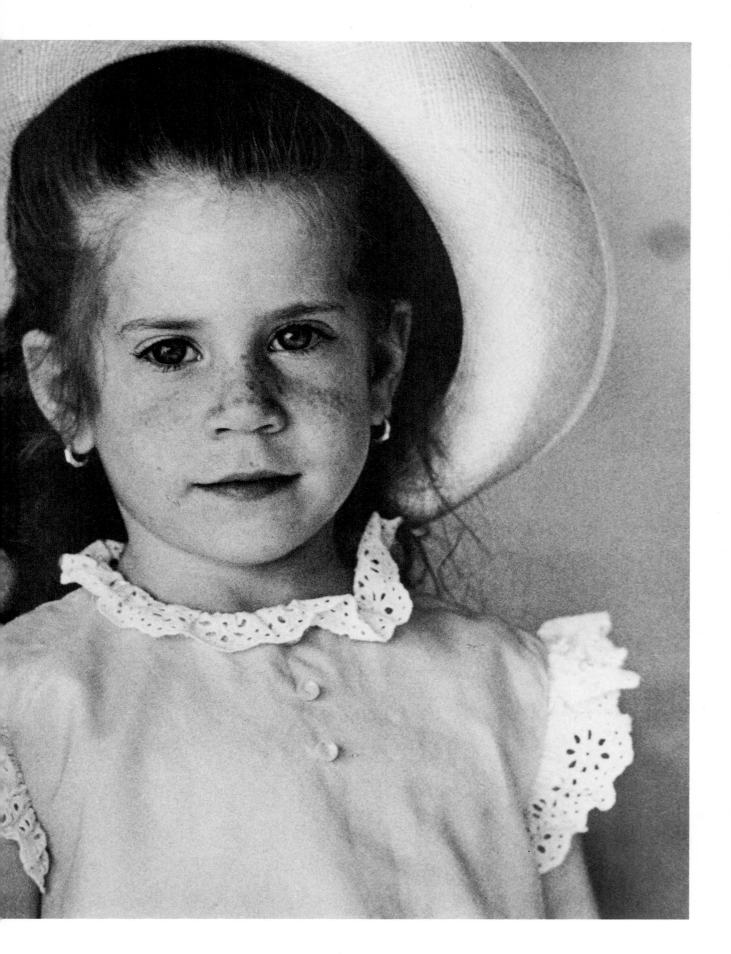

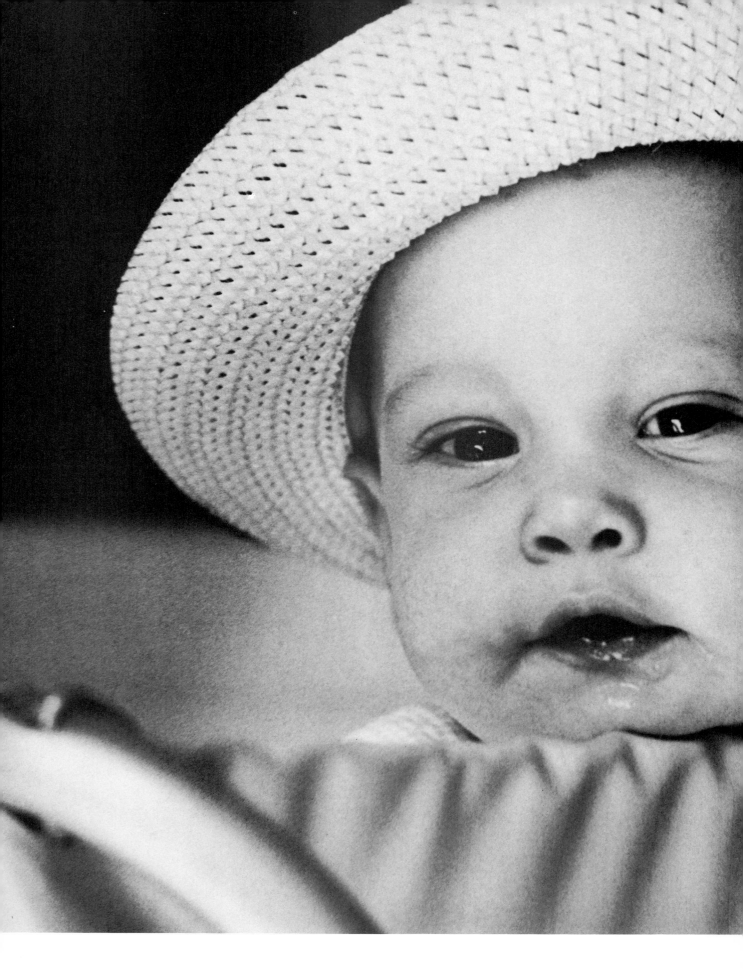

For immediacy and intimacy, shoot at the child's eye level, even when that level is knee-high to a grasshopper.

"Surprise him," says Lewin. "Make unexpected statements, encourage him to be funny, playful." In this kind of situation it can be dramatic to pan with the child: set the shutter speed at 1/15 sec. and follow the child with the camera, slowly squeezing the trigger as you go. This will blur the background while the child remains sharp, and you get the sense of speed, motion, vitality.

But when the child is quiet, dreamy, introspective, talk to him softly and try to bring out the meditative quality you see. "Ask him to pick up something and look for a tiny detail in it," says Lewin. "Or encourage him to sift his fingers through the sand. Or get him to try to see something far away, on a distant horizon."

Equipment, lighting, and shooting techniques. Use equipment, lighting and shooting techniques that will bring out what you see in the child. With the active, outgoing child, for example, Lewin generally chooses a bright, sharp film like Kodachrome 25, often with a pale 05 gel filter the same shade as the predominant color in the photograph: the green of grass, the yellow of the setting sun. This produces a slight but brightening emphasis of that color.

"But for the quiet, dreamy child," she suggests, "use a softer film like Ektachrome. Shoot in the early morning or late afternoon when the light is soft. Try an 05 red or A2 Nikon filter (orange); or maybe a 10 red and 05 yellow used together. To emphasize moody softness, you can rub a little Vaseline around the edge of the gel."

Perspective. In most cases, you'll get the best perspective by shooting from the child's eye level. And in most cases,

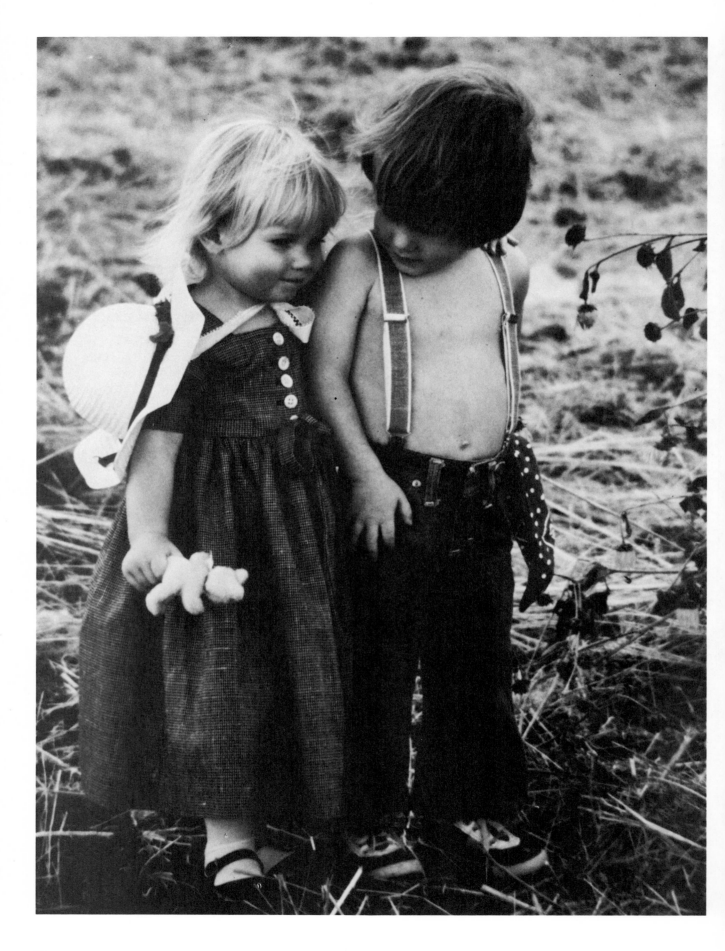

Stiff, formal party clothes often chosen by parents for a picture-taking session tend to produce stiff, formal results. Easygoing playclothes help children feel more normal and less self-conscious, which contributes to a charming image.

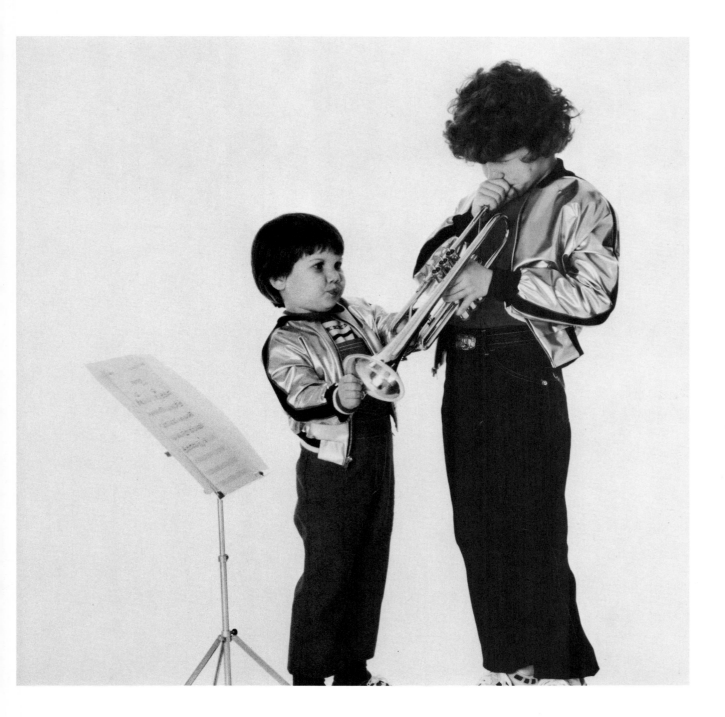

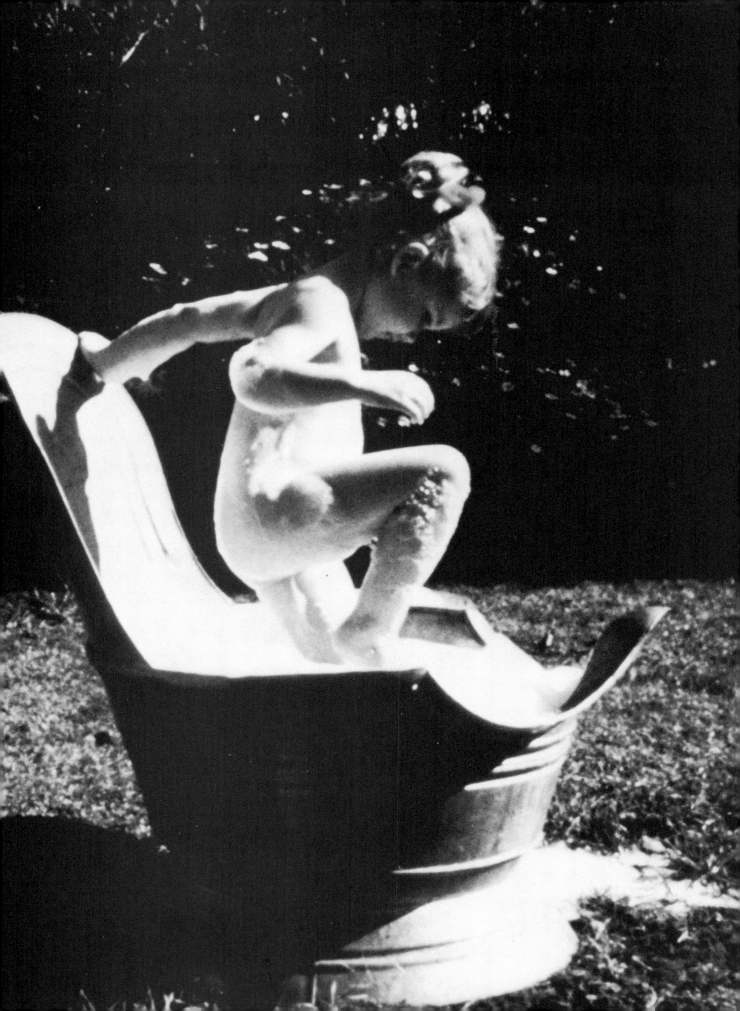

you'll produce the strongest sense of intimacy and immediacy when the child is looking directly into the camera.

But like any general rule, Lewin points out, those two are made to be broken. For example, it is possible to achieve dramatic emphasis by shooting from adult level down to the child. Another favorite setup: the photograph taken indoors, near a window. "Use a fast shutter speed, a large *f*-stop, expose for the highlights, and focus on the eyes," she says. "You'll get an interesting and dramatic result."

Clothing. Don't overlook the importance of clothing. When you're doing portrait work for private clients, the parent will often get the youngster all dressed up in fancy birthday-party clothes—an approach not likely to produce any easy reality you might want. Suggest (tactfully) that less formal garb will help make more spontaneous and appealing photographs. Then go through the child's wardrobe and find something that fits your sense of the child's personality.

For the youngster who's outgoing and active, choose play clothes. If he's something of a clown, you could add a sailor hat or baseball cap. For the wistful, waiflike quality, try clothes that are oversized. Or (as in Lewin's favorite fantasy) dress the child in a long white nightgown.

STAYING IN CONTROL

Back in the dear old Victorian era, most photographers of children persuaded their subjects to "cooperate" by clamping their little heads into position against painted backdrops. The photographs they produced were sometimes winsome but always stilted and about as far as anyone can imagine from the natural look that appeals to us today.

For today's freer, more spontaneous results, the key is to make something happen. You invent situations, then photograph while the child reacts. Though each child's responses will be unique and to some extent unpredictable (that's part of the charm of the business), it's still essential for you to be in control at all times.

As a reasonable alternative to clamps, here are some of Elyse Lewin's suggestions.

Plan ahead carefully. Once you've decided on the environment and basic situations that will bring out what you see in the child, think about all the details. Where do I want the child to be? Where do I want him to move to? What do I want him to reach for? Which way should he be facing, where do I want him to turn to? What exposure will I use? Once the youngster is in the situation and starts responding you'll have to react quickly; so don't bring him in until you have all the answers.

Props. Give the child something to play with, something to pick up and look at, something to do with his hands. The author and photographer Lewis Carroll, of *Alice in Wonderland* fame, was one of the best early photographers of children; and one reason, no doubt, was that he kept his models well-supplied with elaborate toys—everything from music boxes and distorting mirrors to clockwork bears. Such toys not only kept the youngsters entranced but made them less self-conscious.

"But props can be very simple, too," says Lewin. "You can use a ball, a book,

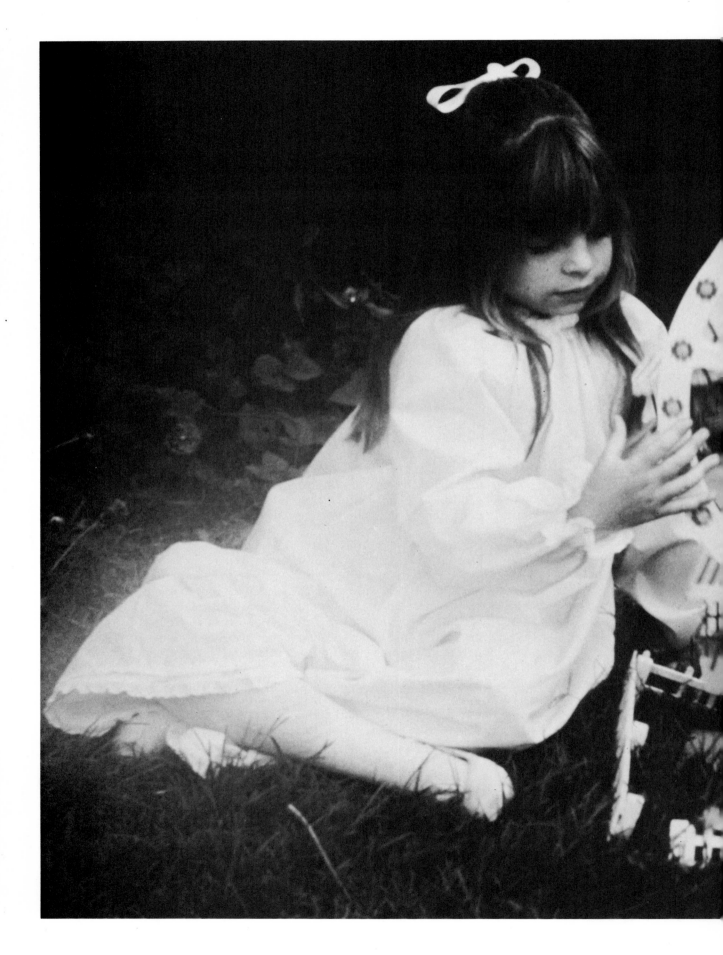

Props make the situation and often the picture. Balloons, musical instruments, tubs, and elaborate toys make children respond spontaneously.

a little jar of bubble-blowing stuff, even a leaf or stick. One photographer I know got a marvelous series of pictures by wrapping a piece of tape around a baby's fingers, then shooting her earnest efforts to get her fingers free."

Babies. When you're working with babies, the only way to control the situation is to immobilize the child. A toddler can be put in a high chair or perched on a hobby horse. With infants, the best bet is to put 'em high: on a table, say, with pillows deployed all around. Another technique is to have the parent, under covers, prop up an unstable infant. Often the baby's hey-look-where-I-am reactions will be all it takes to produce the expressions of surprise and interest and liveliness you want to capture on film.

Work alone. In most cases you'll get the best results working alone with the child, with the parents elsewhere. This is especially true for kids in the contrary, "bratty" stage from three to six, and with older children too. You want them reacting to *you*, not playing out the defy-and-test pattern they may have established with their parents.

It's often easier than you might think to get the total cooperation of an apparently difficult child, Lewin says, and respect is the key. "Make the child feel like a partner in the project, which in fact he or she is. When a kid acts up and won't get with it, I say something like, 'Look, Johnny, we're trying to do something good here, something you and your family will be proud to look at and show to your friends years and years from now. So let's do it right. It'll be fun, you'll see.'"

Treats. Don't let yourself be manipulated into bribing the child to be "good" with food or toys or anything else. That puts them in control. But when you're working with young children especially, you can certainly use treats as unexpected "surprises" for them to discover and respond to while you're shooting. The parent can tell you what's likely to make the child respond with glee or at least with interest: raisins, pretzels, nuts, or even coins. But make it a point to avoid candy or other heavy-duty sweets, Lewin advises, unless you want a sugar-stimulated, hyperactive youngster on your hands.

Keep talking. Lewin's quick-patter monologues are nearly as famous in the industry as her photos. "Never forget that the child is reacting to *you* as well as to the situations you set up," she says. "Kids, like adults, are turned on by praise and encouragement, and the patter keeps them interested, responding, participating. I talk constantly, even to infants. They may not know what I'm saying, but there's no question that they react to my voice and tone."

Speed. Always remember that children's responses are swift and fleeting and their attention span is notoriously short. Once you've set up the shooting situation, brought the child into it, and hooked him into participating, you have to be ready, alert, and very quick. With practically all children you'll get the best reactions during the first half-hour of shooting; with babies, during the first ten minutes. Be prepared to shoot quickly and almost continuously during this prime time.

And never say, "hold it" or "don't move." That in itself can put a nicely thawed-out child right back into deep freeze.

Props give children something to do and make them less self-conscious.

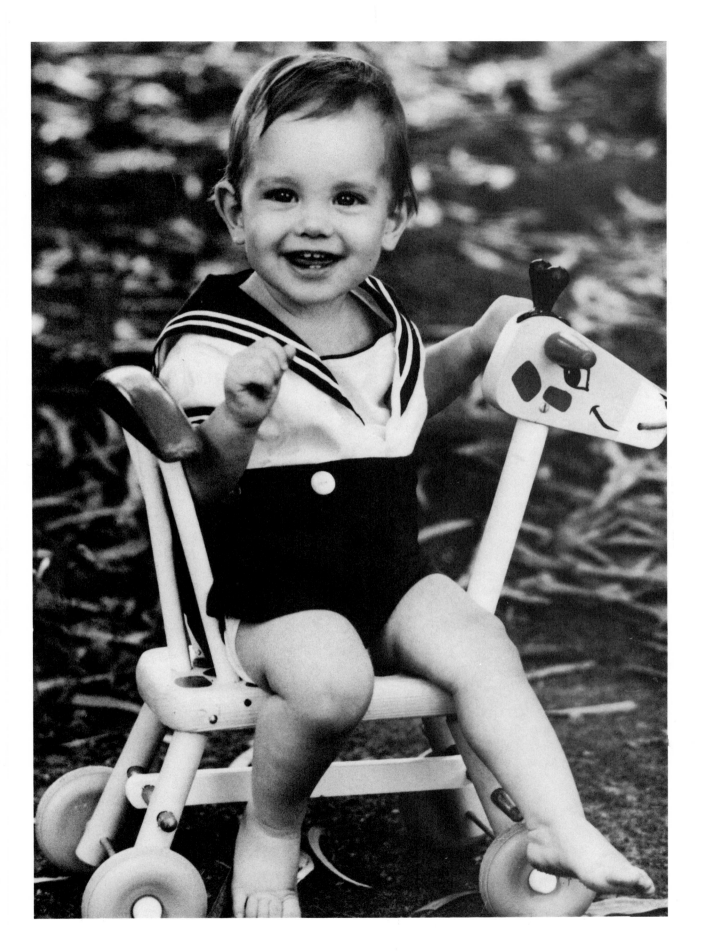

The first rule for taking pictures of very young children is to immobilize them. An immobilizing instrument can be something the child enjoys—a highchair, rocking chair, or hobbyhorse.

A photo of two or more children usually has maximum appeal if the youngsters are interacting with one another (see pages 40–43).

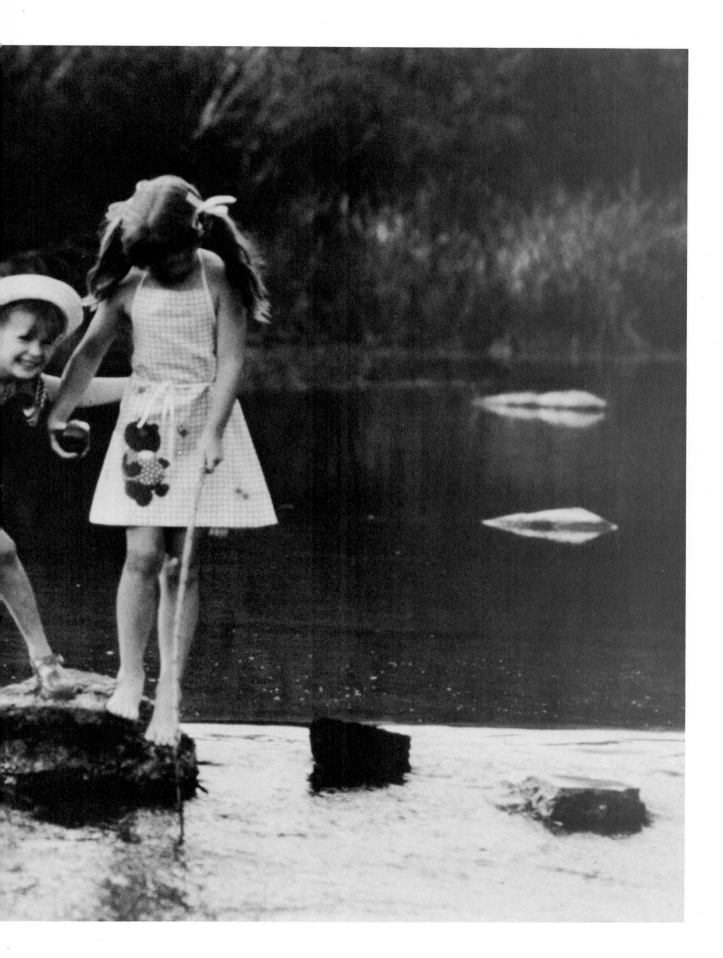

Bringing out different facets of
what you see in a child can call for
different backgrounds and props.
A baseball bat, for example, can
elicit an I-can-beat-anybody
stance; a book, a relaxed pose.

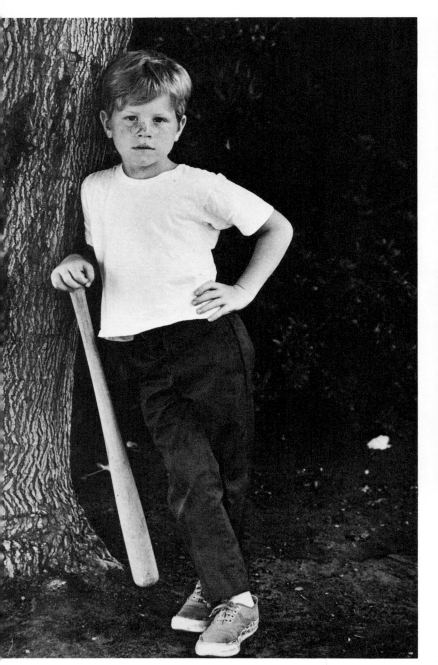

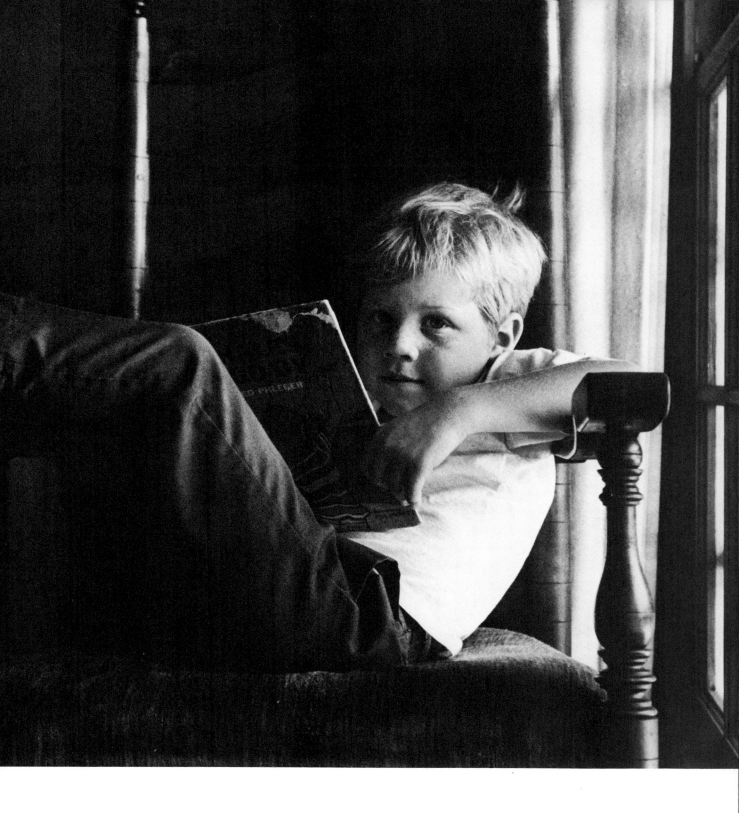

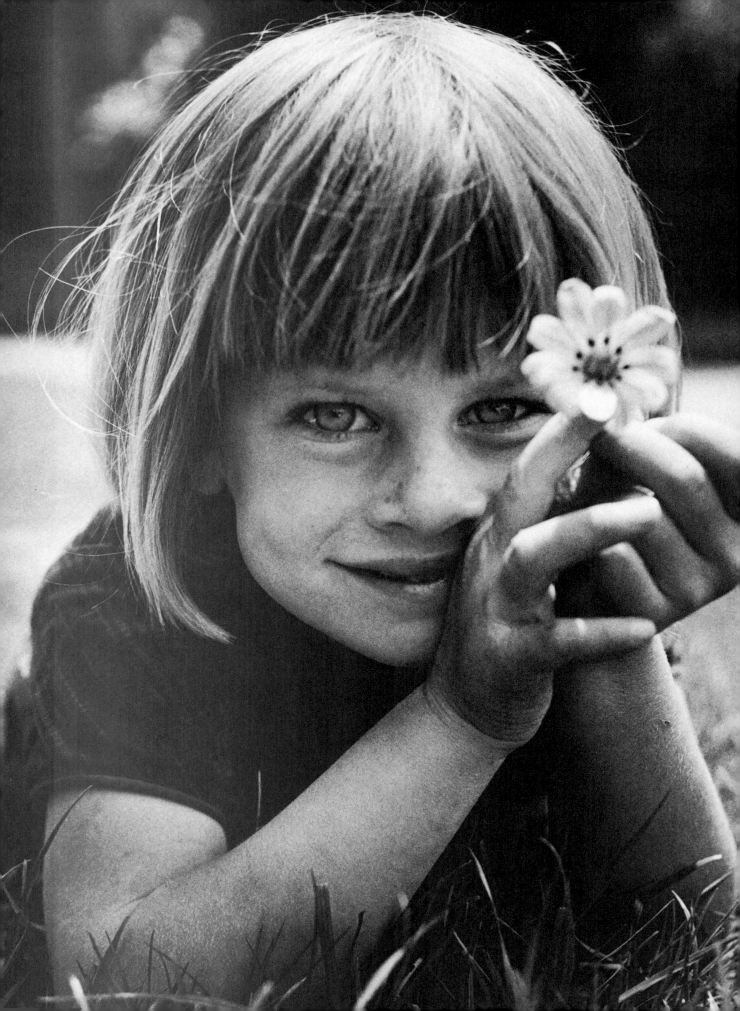

CHAPTER THREE

The Basic Equipment

ONE PRIME ATTRACTION of professional child photography is that the initial cash investment can be very low. When you follow the Lewin formula for getting started—that is, shooting on location, in or near the homes of private clients—you can easily get by without a studio. Furthermore, many serious non-professional photographers will already own most of what's needed.

Here's a rundown on the equipment priorities for the beginner in the child photography business. For recommendations on studio equipment and layout, see Chapter 6, *Setting Up a Studio.*

CAMERA AND LENSES

Photography for private clients is generally known as "portrait" work, but when the subjects are children that term is deceptive. "Portrait" conveys the impression of something posed and static, and first-rate child photography should be anything but that. It's essentially action shooting, even when (as with "immobilized" babies, for example) the action may consist only of small, subtle but important changes in facial expression and body language. Once the child starts responding to you and the situations you contrive, you have to be prepared to shoot a continuum of action and expression. Clearly, then, speed has to be a decisive factor in your choice of equipment.

Elyse Lewin started her professional career with a 2¼-square Rollei. But early on she switched to a Nikon, and she regards a good 35mm camera as the indispensable tool for photographing kids in a non-studio setting. It's mobile, versatile, fast and relatively unobtrusive. Just as important, it will hold 36-exposure film, so once you start shooting there'll be a minimum number of interruptions for reloading—and since the average youngster's best responses come early and end soon, that's crucial.

In most cases, you'll shoot at the fastest speed available and compensate by using the widest *f*-stop. This reduces depth of field, of course, and may, produce an out-of-focus background, but for portrait work that's usually desirable anyway.

"Amateurs often judge the quality of a picture by the sharpness of background

Outdoor lighting is best for soft, natural illumination. Lewin uses Kodak Tri-X film for most black-and-white outdoor shooting. It's fast and soft and has rich gradations in tone.

detail," Lewin says, "but in professional child photography this is often irrelevant. It's true that in some advertising shots everything has to be in clean, crisp focus: the child, the background, and certainly the product. . . . But in portrait work for private clients . . . and for many advertising and editorial assignments, too . . . it's not the background that counts. It's the child."

That fact should also figure heavily in your choice of lenses. Even when you've set up a "controlled" situation for the child to respond to, he still has to be regarded as a moving subject. And because intimacy and closeness are essential, you need the ability to zero in on the subject and his quick reactions no matter where he moves. This is why Lewin puts zoom lenses at the top of the priorities list; other lenses can come later, as your budget allows.

For starters, you'll get the coverage you need with two zooms: say, a 43mm–86mm lens and a 90mm–200mm lens. You may get blurred backgrounds with the longer lens, but as noted above, it's the child that counts.

LIGHTING EQUIPMENT
The outdoors is a child's natural setting, and the outdoor light of a warm, sunny afternoon is the natural choice for photos of children. Lewin likes indoor shots with the same warm, natural ambience, and often achieves it by mixing reflected or artificial light with the daylight from a nearby window.

Reflectors. A big sheet of white cardboard is a low-cost and surprisingly versatile reflector. Use a 4 x 8-foot (1.2 x 2.4m) sheet if you can manage the bulk, a 2½ x 4-foot (0.8 x 1.2m) card if you

Left. Shooting a continuum of actions and expressions produces small, subtle differences. It also makes for natural-looking photos. A versatile, fast 35mm camera is recommended for portraits. Such a camera will also work well in non-studio commercial settings.

Right. It's the child that counts. Shooting at a fast speed and at the widest *f*-stop may reduce your depth of field, and blur the background, but it won't detract from the appeal of the photograph.

Left. A blurred background produced by a telephoto lens is no drawback in portrait shooting. It may even be desirable for some commercial work. This photo was used by Peterson Baby Products.

First-rate child photography should be anything but static. The action may be simple, subtle, yet crucial changes in body movement and expression.

can't. Put it on or against a chair where it will reflect the light from the window and bounce it back onto the subject. When the child is facing the window you get full natural light. When he turns away you get sidelighting or backlighting from the window, plus "fill light" (so-called because it "fills" the shadows) from the reflector.

Other reflecting devices can be equally handy. Some photographers use crinkled aluminum foil glued to a sheet of cardboard; some prefer a cloth that's white on one side, silver on the other. For added warmth, Lewin prefers gold foil or white cardboard with amber gel taped to it.

Additional lights. A standard 500-watt flood lamp increases your indoor options. When there's a flood lamp on one side of the subject and a window on the other, the daylight is still the main source of illumination but the flood lamp highlights hair, eyes, etc., and generally brightens the scene. Lewin often uses a No. 10 red filter to warm up the daylight/flood lamp mix.

Quartz lights are inexpensive, compact, and brighter than standard flood lamps; a single bulb can produce 1000 watts. "Quartz light mixes well with daylight, too," says Lewin. "Aimed directly at the subject, it makes a warm lamplight effect. But the light is too impressionistic for some uses."

Keep in mind that both standard flood lamps and quartz lights are hot and glaring, and they're best used briefly and carefully with kids. Be sure to locate lights, stands and cords in a way that minimizes the likelihood of touching and tripping.

Electronic flash is cool because it's so

An indoor shooting site arranged near a window makes maximum use of natural outdoor light. Shadows can be filled by adding artificial light or any of several reflective devices (see pages 52–55).

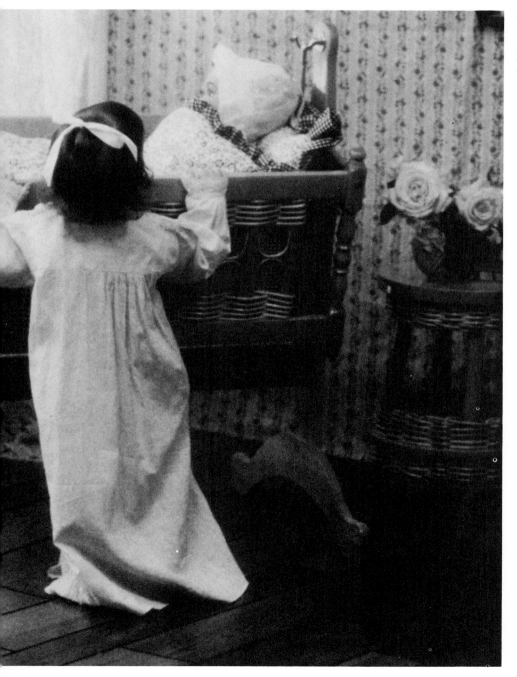

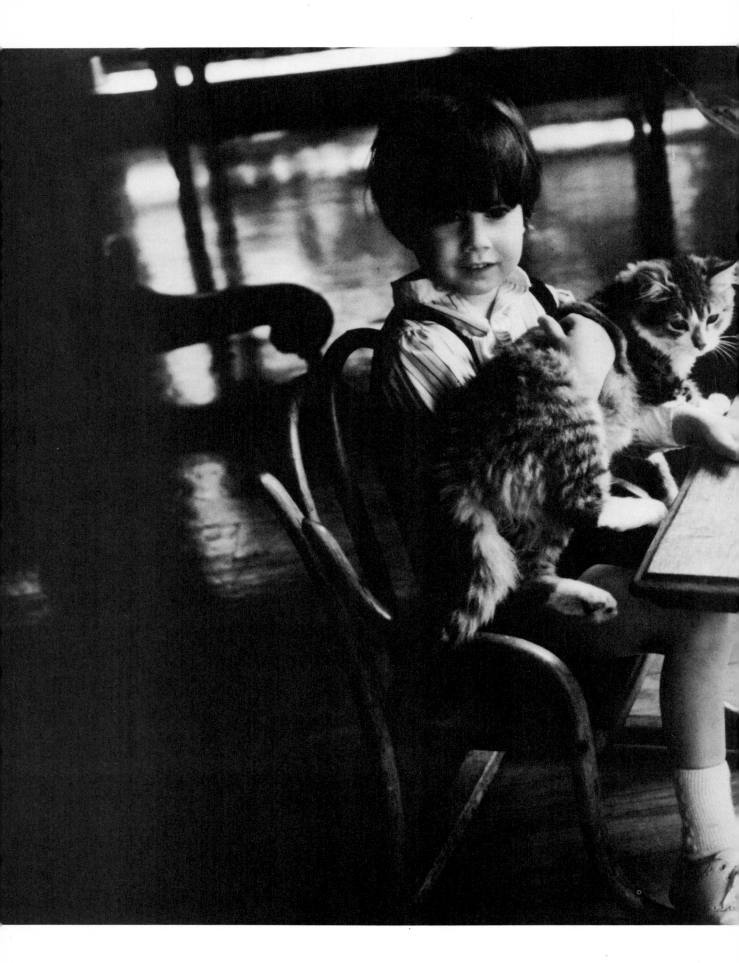

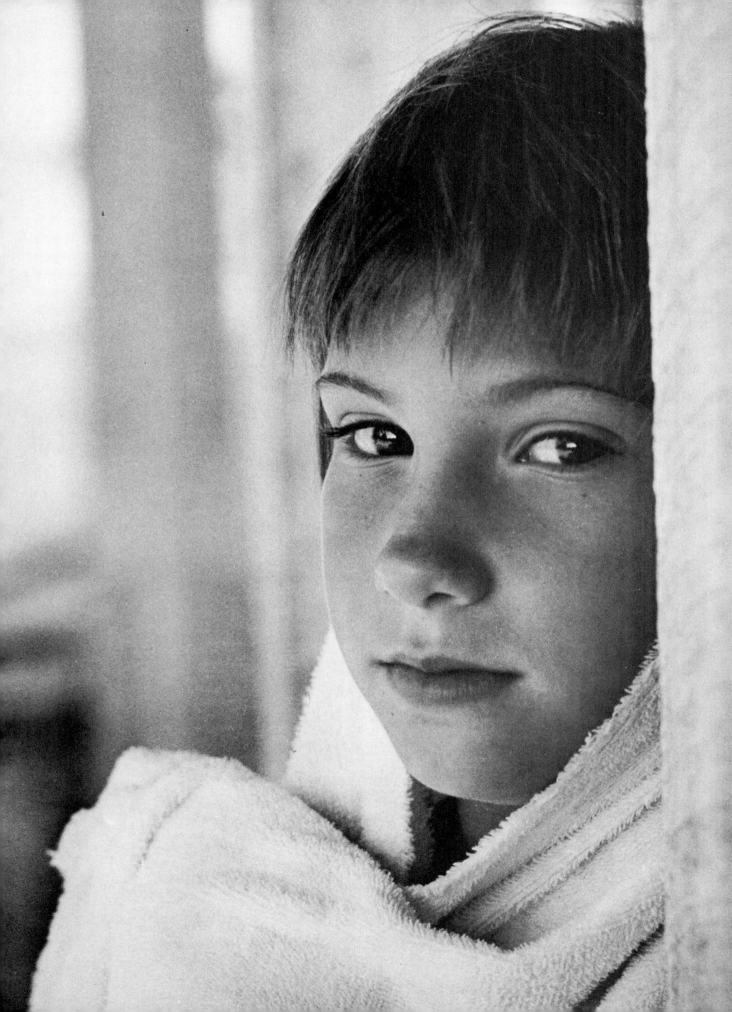

Left. A mix of natural and artificial light often produces the best photos. Natural light produces crisp but soft images, while well-located floodlights highlight the eyes and facial details.

Right. A Lewin picture often shows a child with daisies. ''My little girls with daisies are almost a cliché,'' she says. The flowers give the child something to look at and something to do. They also function as a design element.

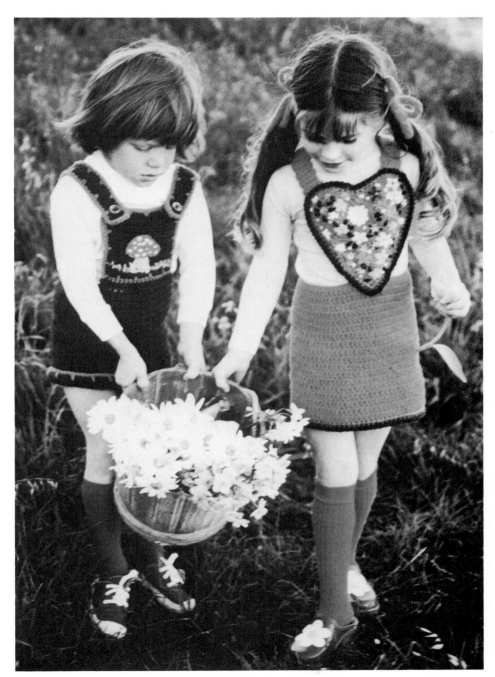

brief, and the average photographer turns to it almost reflexively for action or "continuum" shooting. But not Lewin, who uses it primarily in the studio, seldom on location work with children. The reason: in the studio because you are controlling all the variables you can pre-test the flash and thus predict its effect on the scene; on location you can't. When you use daylight, reflectors and flood lamps—alone or in any combination—what you see with your eye is what you'll get on film.

FILM AND FILTERS
Lewin uses Kodak Tri-X for black-and-white shooting, and when a situation calls for brisk, crisp, high-saturation color, her usual choice of film is Kodachrome 25.

But what she generally wants to bring out in children is their soft charm and ingenuous beauty. To do this, she often wants color that's soft, gentle, even hazy, and for those effects her film choice is high-speed Ektachrome 400. One reason is that Ektachrome is inherently "softer" than Kodachrome. Another is that it can be corrected and manipulated in processing, either in a home lab or at a commercial lab that does custom work. This gives you all kinds of options. When you want a warm, diffused, romantically "grainy" image, for example, you can underexpose the film when you're shooting and then have it overdeveloped in the lab. Or you can do the opposite: when you overexpose and underdevelop, the film tends to "drop color," and you get a result that's muted, pastel, low in contrast.

It's important to know also that even though the manufacture of film is as standardized as a robot-operated assembly line, different batches tend to have slightly different emulsion characteristics. For this reason Lewin buys her film by the case whenever possible, and in large quantities when it's not. She then pre-tests the first roll in each batch by shooting it in an average lighting situation. Similarly, every processing lab uses slightly different chemical combinations; to minimize the variables, always take your film to the same lab.

Like practically all professional photographers, Lewin refines light and color by using gel filters. Some of her filter habits are unorthodox. For example, she might use a pale-blue or green filter to intensify the predominant outdoor color ("What are you *doing*, Elyse," says the client, "those kids are gonna turn out *green*!"). But most often she uses filters that will give the scene the rosy, golden glow of a summer afternoon: an 81A or 81B (yellow-orange), 10Y (yellow), and 10 R (red). To soften the hard white light of electronic flash, she covers the flash with a gelatin sheet widely and weirdly known as "bastard amber."

What herbs and seasonings are to the chef, gel filters are to the photographer. They can be used on cameras, lights and enlargers; they can be doubled for emphasis, color-mixed for different effects. But useful as they are, they can also be tricky; before you work with a new filter or a new combination, test it in advance with exactly the film and the lighting you'll be using on the job. The wrong intensification or correction can be as obtrusive as garlic in a milkshake.

When the child is facing the window you get full natural light. What you see with your eyes is what you'll get on film.

The outdoors is a child's natural setting. A warm, sunny afternoon is a perfect time for photographing children.

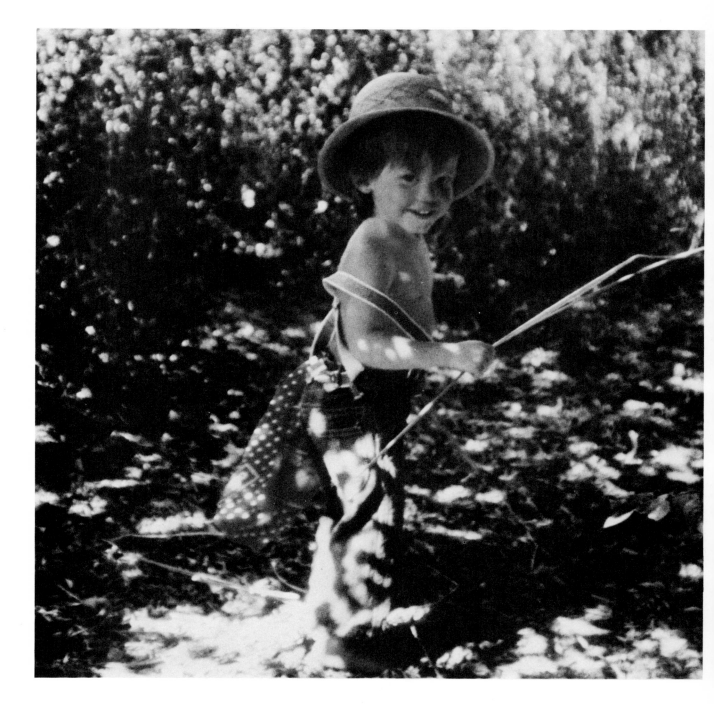

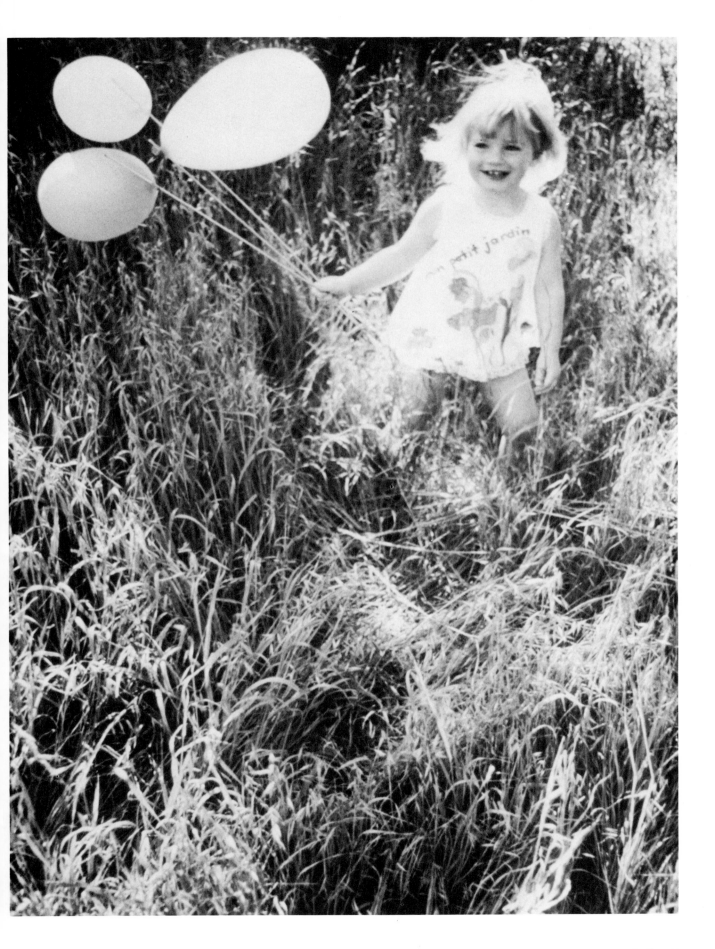

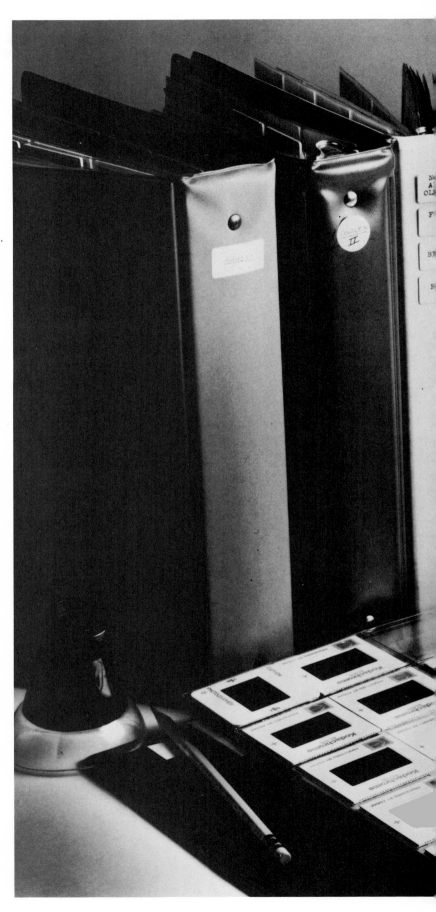

PACKING IT TO GO

On a typical location job, you'll be hauling at least these basic pieces of equipment:

- Camera, lenses, filters.
- Lighting equipment.
- Film (at least six 36-exposure rolls, says Lewin, even though the average child's responses will start dimming after four).
- Miscellany like lens-cleaning tissue and fluid, marking pens, notebook, tape.

To carry all this equipment and keep it quickly accessible, you'll need a lightweight carryall with plenty of individual sections or pockets. Some photographers feel secure only with a hard-sided case, usually made of aluminum or fiberglass. Others use the metal or canvas carryalls designed for fishermen since their multitudinous compartments work as well for lenses as for lures. Lewin currently hauls her portable gear in a light, shoulder-strapped canvas bag with lots of pockets.

Whatever you use, organize and pack your gear methodically. Decide on a specific slot for each item and use the same space every time, so that when you reach for a lens or a filter or another roll of film you can put your hand on it immediately. Never forget that when you're working with children, every minute counts.

STORING YOUR PHOTOGRAPHS

As time passes, your original negatives and transparencies will be like money in the bank. You'll sell many photographs not just once, but many times. In the meantime, you need to store them

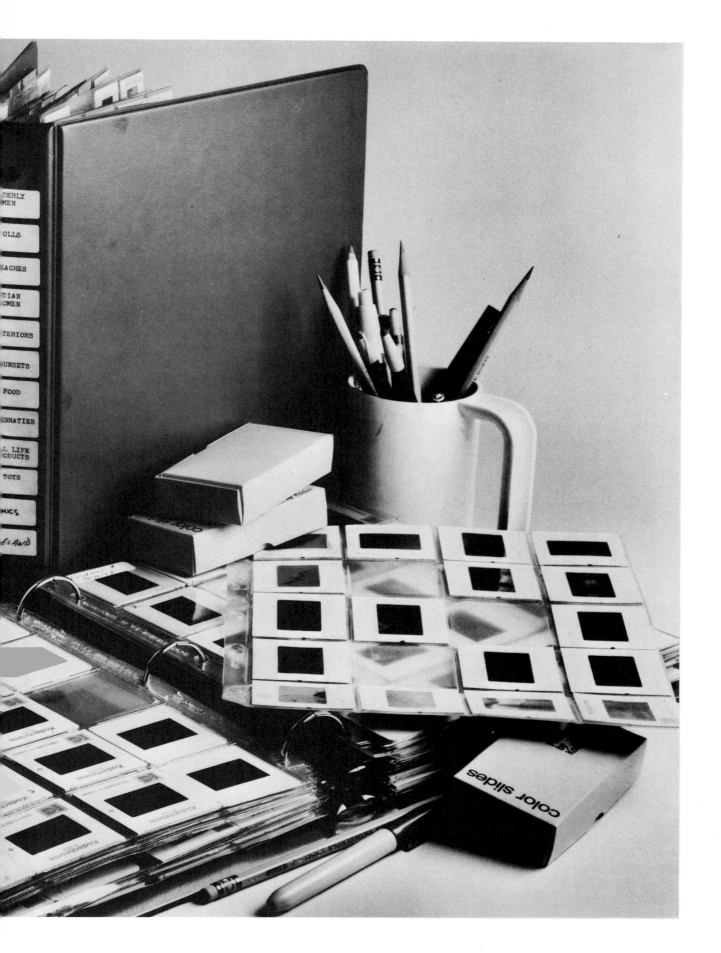

so they'll be both safe and easily accessible.

Negatives. Black-and-white negatives are easy to keep in 8¼″ × 11″ (21 × 28cm) negative file envelopes. These can then be put into standard file folders and stored in standard-sized filing cabinets. Always make a contact proof-sheet for yourself and file it with the negative envelope. That way you'll be able to see exactly what you've got without having to handle the negatives.

Transparencies. Color transparencies need to be stored in a spot that is cool and dry. There are several brands of plastic sleeves which have pockets for 20 transparencies. The sleeves can be kept in a three-ring binder or can be filed in folders and in standard filing cabinets. Some photographers keep transparencies in slotted metal boxes (available at most camera shops) which can be labeled and stacked.

Numbering. In order to keep track of your inventory, you have to number everything in your negative/transparency files, and use the numbers in conjunction with a desk-type index-card or Rolodex file. Use a base number for each job or assignment, plus a sub-number for each transparency or frame (for example, 183-22). The job number goes on each contact sheet and on the negative/ transparency folder, binder or box; frame numbers can be noted on contact sheets or transparency mounts. The full number (job number and individual-shot number) should go on the back of every print you sell, so that when a customer orders more copies of a specific print you'll know exactly what's wanted.

The numbers—job number and sub-numbers of shots sold—will also go on the corresponding card in your index file. When you work for private clients only, a card file organized alphabetically by customer name will probably be all you need to stay on top of your inventory. But when you start selling to other markets, you'll also need a cross-indexing system with the cards organized by *subject*, like "Infants, crying"; "Infants, playing"; "Infants, with mother," and so on. More about all that later.

Lewin looks for more than just cuteness or good looks in a child model. She seeks those that "have an innate charm of movement."

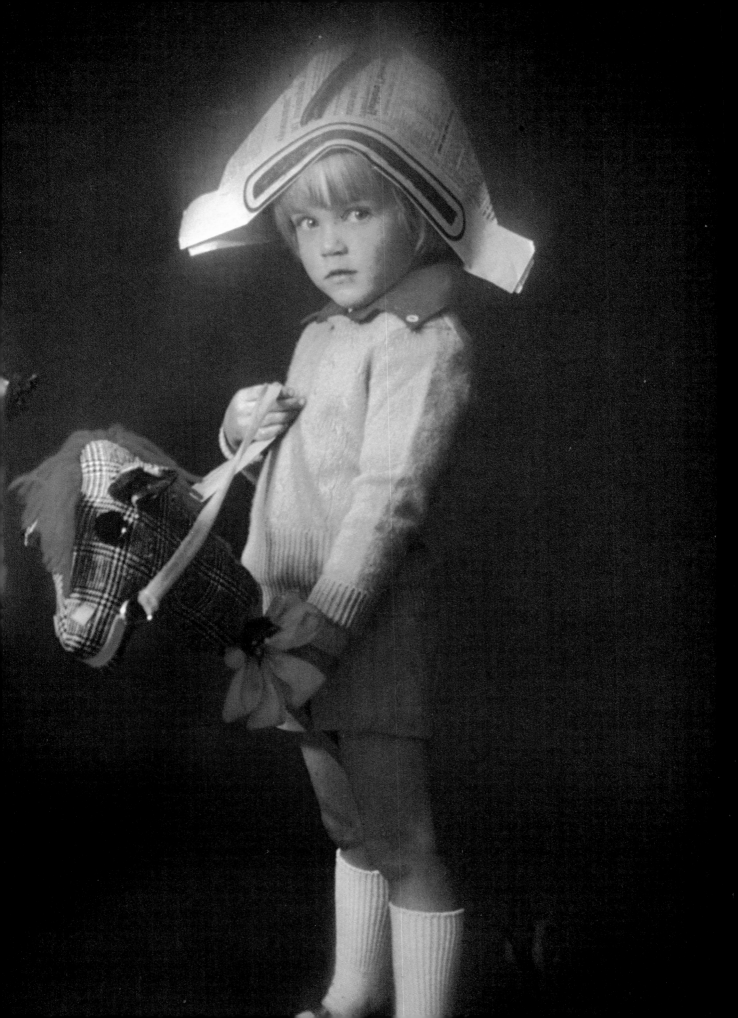

Warm light from the window and effective use of props made this shot for Mattel a success.

The pale-yellow filter has given a romantic glow. Compare the different feeling which was obtained when the filter was not used.

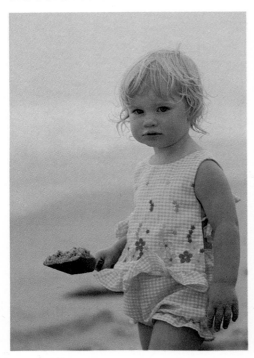

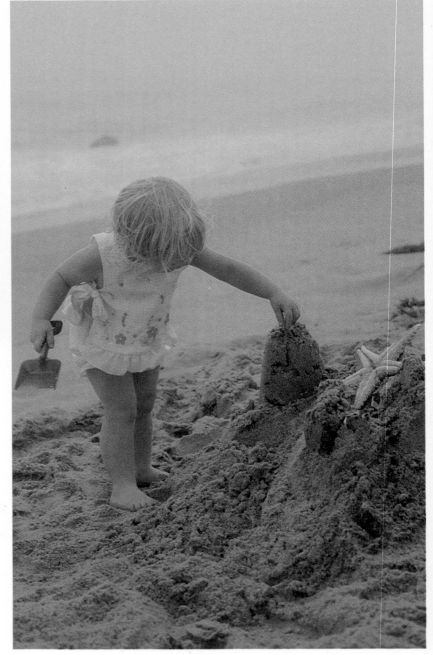

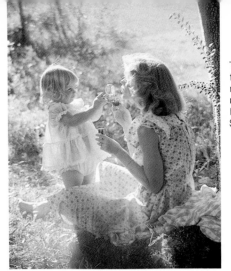

This combination of backlighting, fill, and a pale-magenta filter makes motherhood seem very romantic. This image was used to illustrate a promotional calendar in Southern California.

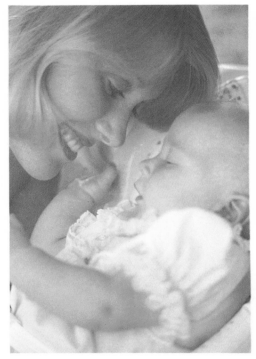

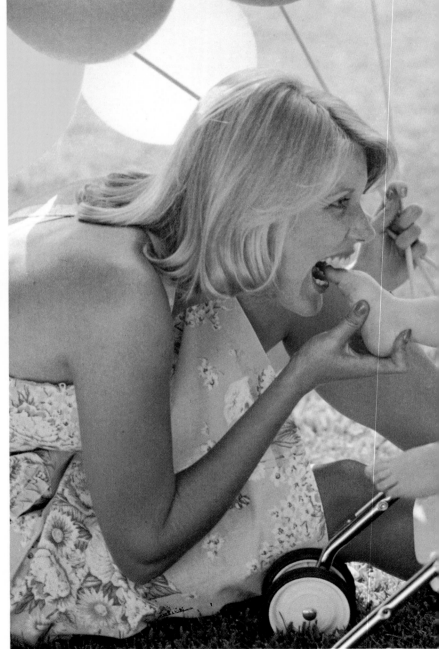

Mother and infant relating. A closeup produced an intimate portrait. Stepping back a bit Lewin caught a playful moment. Either of these would appeal to both private and commercial clients.

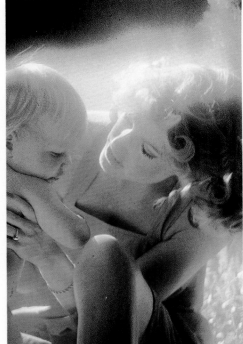

Soft diffused, backlighting creates a romantic mood. Diffusion or fog filters can also produce this effect.

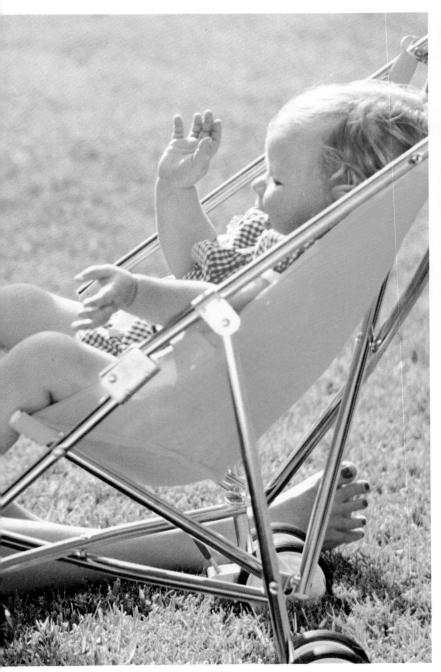

Children need not be all dressed up. Photographing them in play-clothes can produce relaxed expressions.

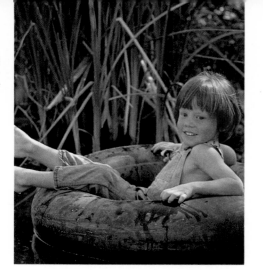

Right. Filters can powerfully affect the mood of a photo. In the photo of the two girls in the meadow a pale-green filter has given a springlike feeling to an outdoor setting. Notice the dreamy feeling. The girls are in their own world, unaware of the camera.

Below right. Lewin often uses filters to emphasize the predominant outdoor color. In this illustration for an article on dollhouses, a pale-green filter subtly accented the combination of a dreamy child with a magical toy.

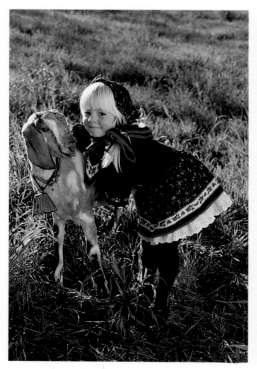

Another way to get natural expressions is to allow the child to play with an animal. The animal provides a diversion for the child.

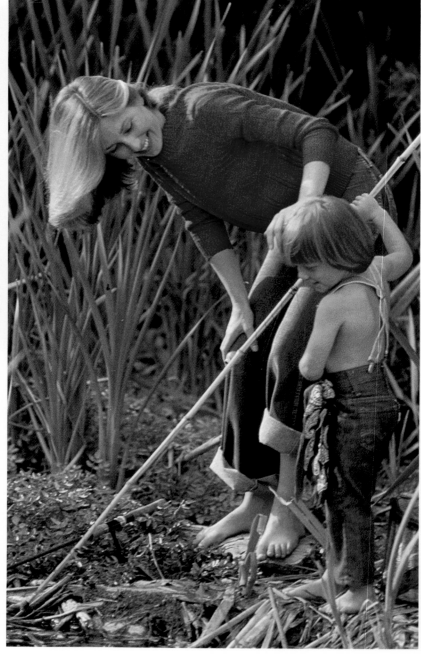

Kodachrome 25 should be used if you want vivid, highly saturated color. This shot combines brilliant colors with a wholesome grass-roots concept. It was used by Kodak in a promotion piece.

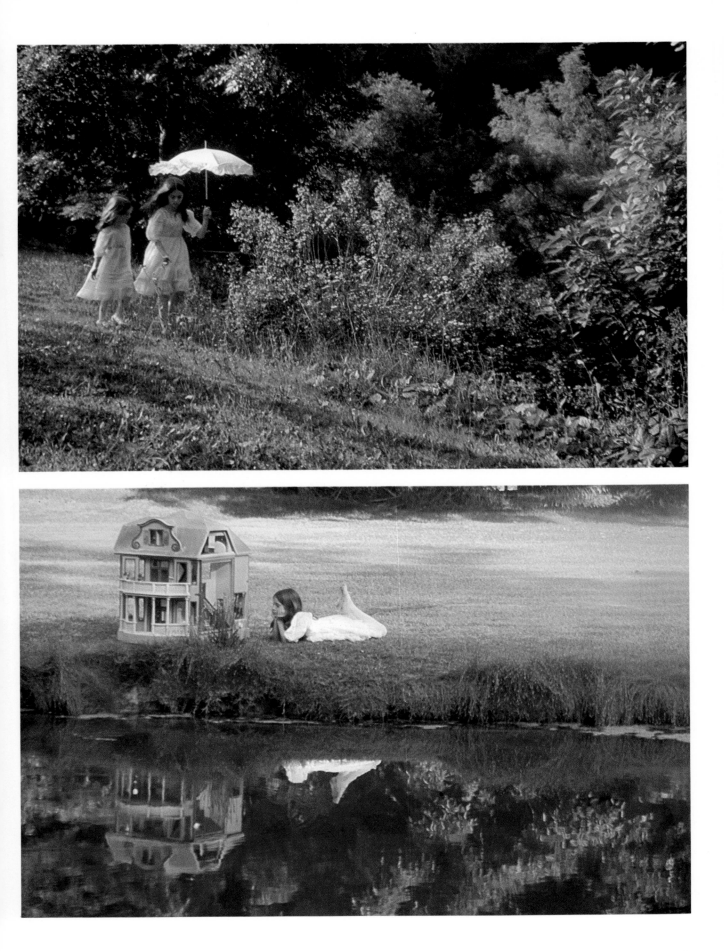

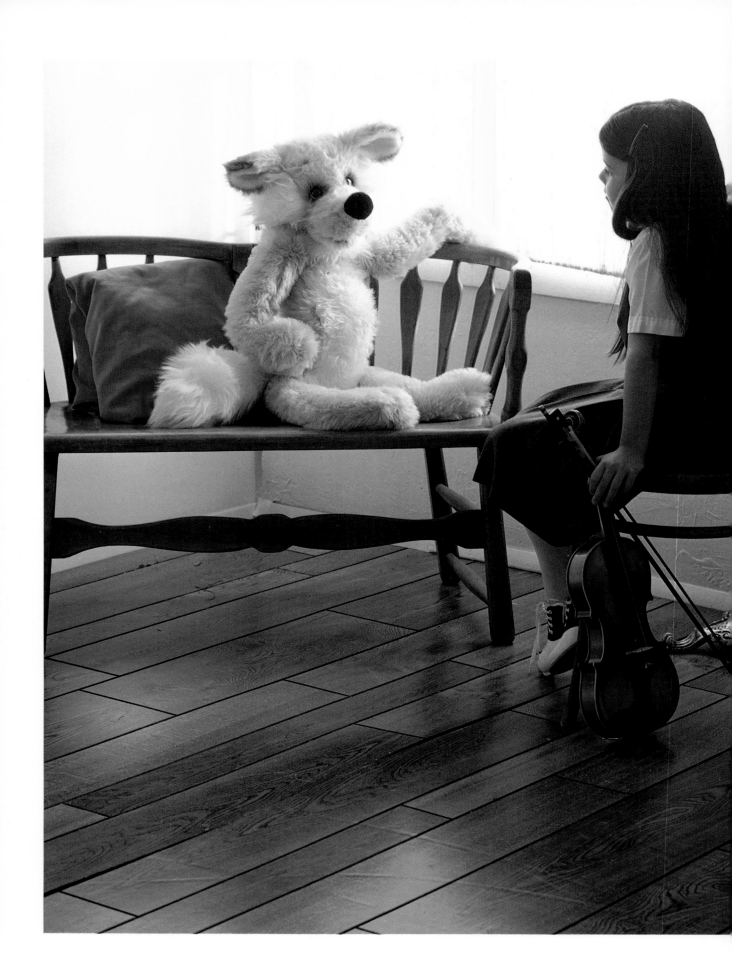

Window light can be used to produce different moods. The photo of the girl and her bear has strong shadows and gives a feeling of peace and calm.

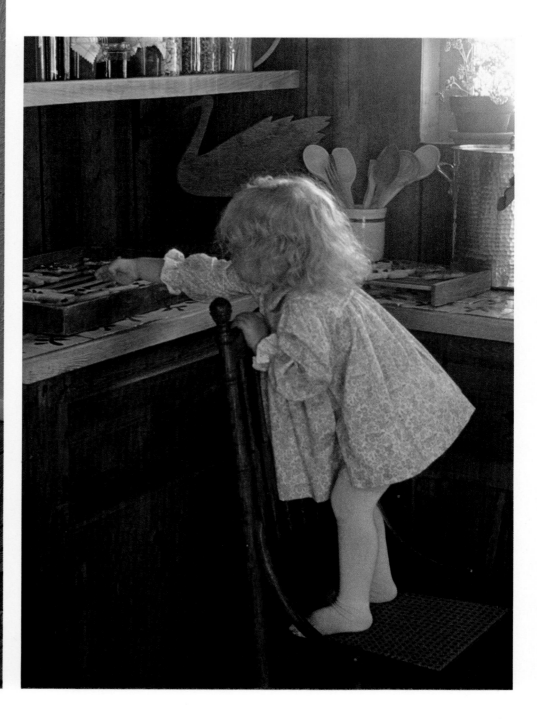

Diffused, romantic color and window lighting are appropriate for the nostalgic concept of these photos.

A warming filter in the yellow-orange range makes a warm, sunny afternoon look even warmer. Gel filters, which can be used on cameras or on lights, are the usual choice of professionals.

These photographs have editorial potential. Research a publication before submitting your work and try to think of what kind of photos it might be most likely to need.

How do you get a baby to respond? Put something in his hand and toss a blanket on him. Then click the shutter quickly. Most infants are used up after ten minutes of shooting.

This infant was given something to keep himself busy with, which provided for a natural, spontaneous reaction.

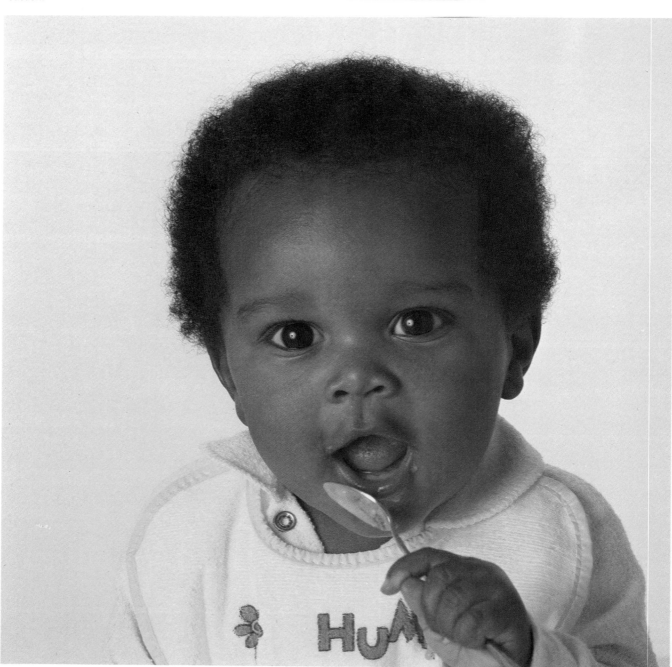

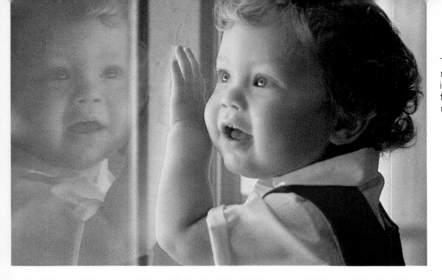

To children the world is one big
mystery. They can find enjoyment
in something as simple as their re-
flection. Try to capture these natu-
ral reactions.

Below and overleaf. In advertising
work the product, not only the
child, must be appealing and
shown in detail.

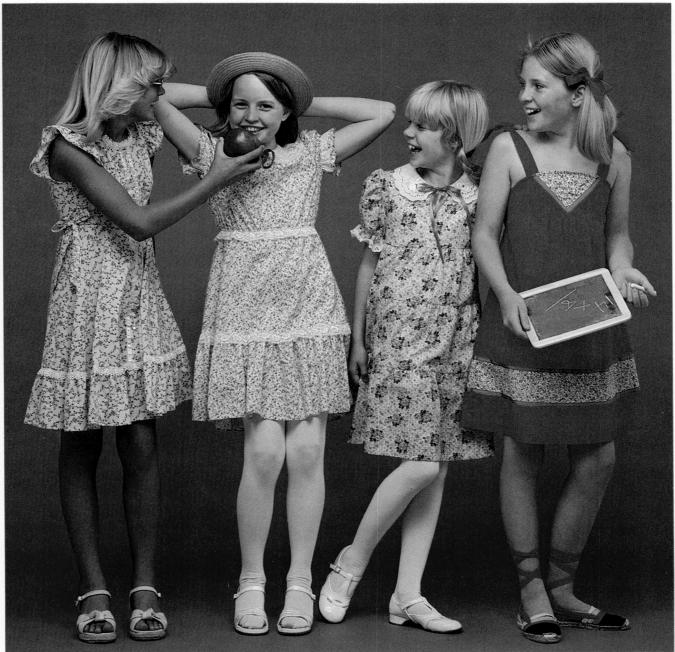

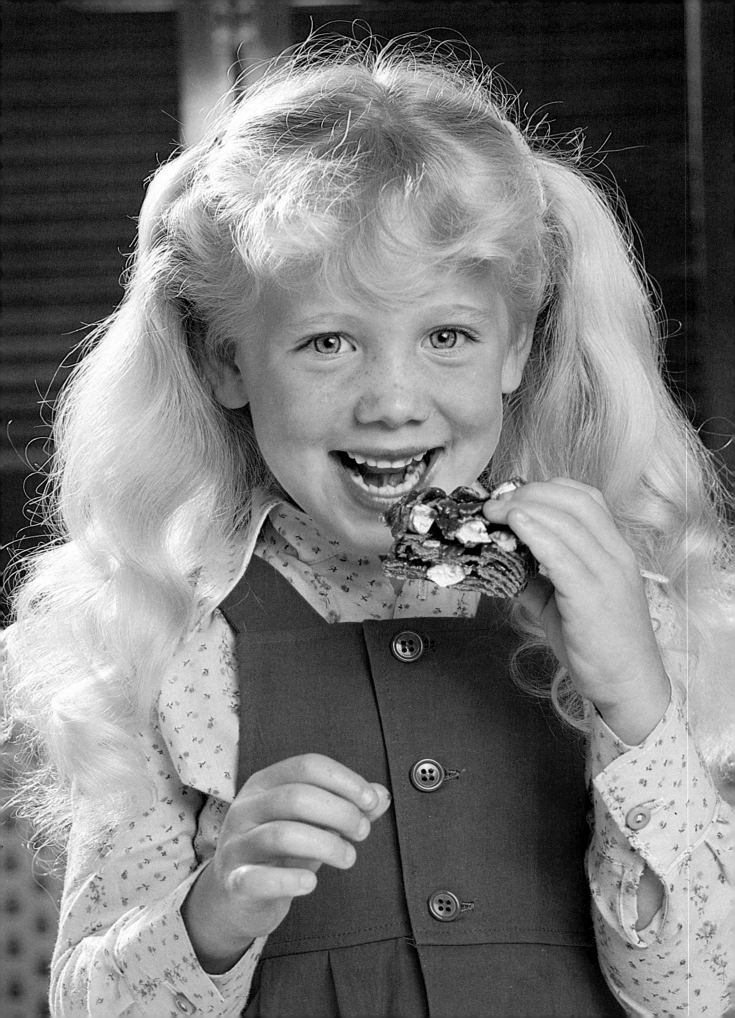

Portrait Photography: Working with Private Clients

ORTRAIT WORK offers the quickest, easiest way of entering into professional child photography. It lends itself perfectly to part-time, home-based operation: you shoot "by appointment only," in or around your clients' homes and at special events such as christenings or parties. Portrait work can be a lucrative end in itself, or it can lead to (and finance) a studio-based business with commercial clients.

Portrait customers can be as close as your next-door neighbor, and compared to advertising and editorial clients, they're generally very easy to please. They are, after all, pre-sold on the subject matter: their own kids. As long as you have the essential ingredient of being "good with children" and knowing how to bring out the basic charm of each child, you'll have no trouble getting and keeping customers, even if your professional skills are less than perfect to begin with. Naturally, those skills will improve with time and experience . . . which is why portrait work can serve as a kind of technical apprenticeship for editorial and advertising work.

Your start as a professional can be as informal as Elyse Lewin's: a word to a neighbor or two that leads to your first job and then to word-of-mouth referrals. Or you can tell your community you're in business by buying classifieds or small display ads in local newspapers. You can buy space in the Yellow Pages. You can also post business cards or printed flyers on shopping-center or other community-type bulletin boards. Keep in mind, though, that any printed material you use, from business cards on up, should be first-rate in conception and execution. As a photographer you are, after all, in the business of graphic images, and anything with your name on it must look good.

PROMOTION

Conventional advertising— be it newspaper space or printed brochures or whatever—costs money, sometimes a lot of it. On the other hand, well-thought-out promotional efforts may cost you time (which most beginners have more of) and only a small outlay for materials. Besides, they can help you establish yourself more quickly and often much more effectively than paid advertising.

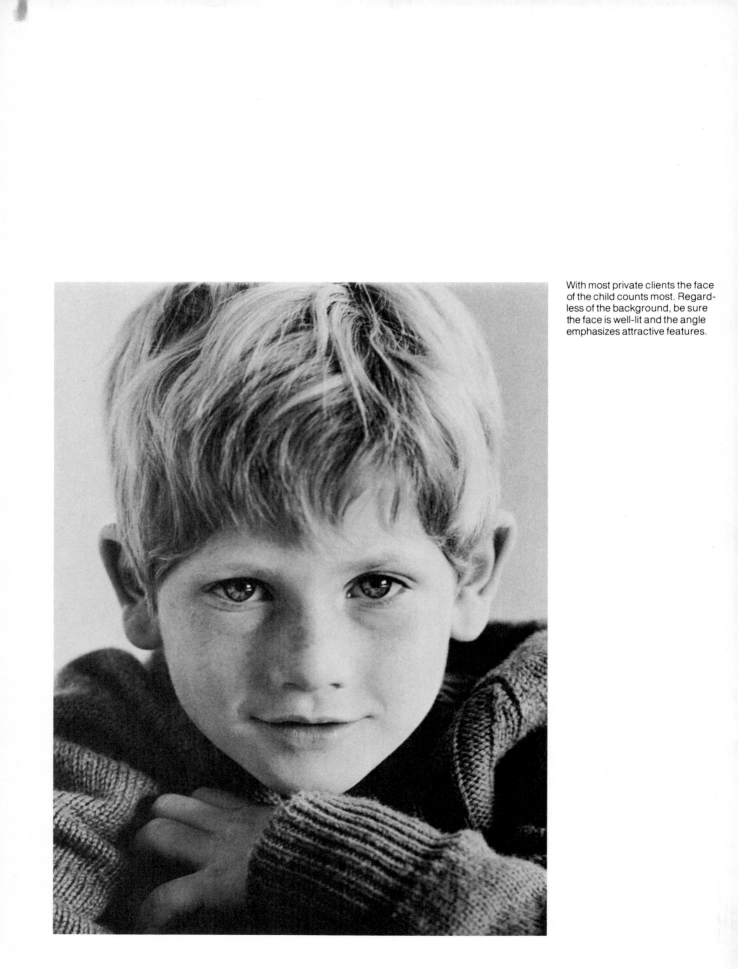

With most private clients the face of the child counts most. Regardless of the background, be sure the face is well-lit and the angle emphasizes attractive features.

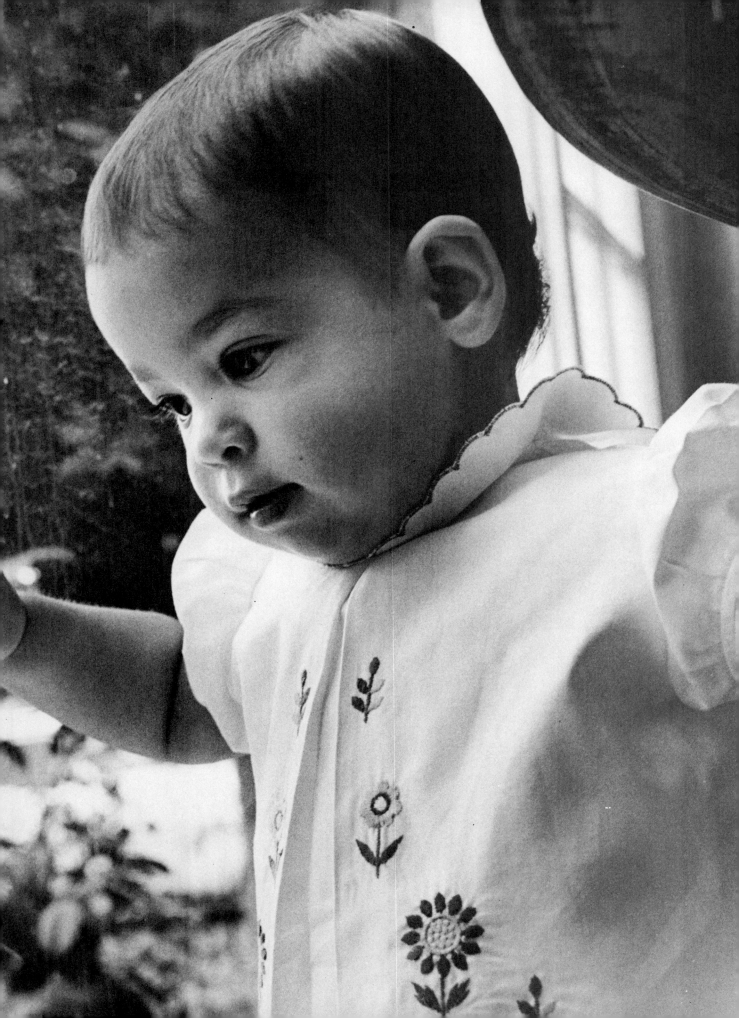

As you acquire confidence and begin to expand beyond the neighborhood, a prime target for your business will be well-to-do parents. These people are often easiest to reach not by advertising but by promotion, especially through local merchants such as hairdressers or boutique owners who have contact with them regularly.

Early in her career, for instance, Lewin worked out a neat promotional exchange with a manicurist in an expensive beauty shop. She shot pictures of the woman's grandchildren for free, and put the best of them in an attractive loose-leaf booklet. The proud grandma showed the book to all her clients, some of whom soon became Lewin's clients. The owner of a Beverly Hills boutique participated in a similar arrangement. In exchange for free photos of her own children, she let Lewin put an attractive photo display in her shop—accompanied, of course, by a discreet card identifying the photographer's name and phone number.

Another good source of promotion is the local camera dealer. Lewin mounted an annual "Children of the Year" photo exhibit (accompanied by a promotional card) at the camera store where she did business, and sent cards to her clients whose youngsters were on display. The parents were flattered and brought friends and relatives to see the exhibit. The store got new customers, and Lewin got new clients—including some, no doubt, who hoped that their kids would be in *next* year's show.

Good community relations can pay handsome dividends. You might, for example, offer free coverage of some community event involving children: a

CHILDREN

AN EXHIBITION OF RECENT PHOTOS BY

ELYSE LEWIN

OCTOBER 18 - NOVEMBER 18

BEVERLY HILLS CAMERA SHOP
417 NORTH BEVERLY DRIVE

A good shot from a set of private-client photos makes an appealing mailing piece for Lewin's annual exhibit at a local camera store.

Little League playoff, a school play, a Christmas party at a children's hospital. You give the sponsoring organization a booklet or a mounted collage of the best shots—and you probably get additional print orders from parents, a display spot in the lobby, or a grateful mention in the organization's newsletter. If the event produces some particularly compelling action or human-interest shots, offer them immediately to the local newspaper. The paper may give you a fee (usually small), a credit line (better), or both (best of all). Publication always increases your value in the eyes of private clients.

HOW MUCH TO CHARGE?

That question, says Lewin, always reminds her of the story about the man who sold eyeglasses:

"How much are these?" says the customer.

"They're $100," he says. And when he sees no visible signs of protest or panic, he adds, ". . . for the frame, of course."

"And the lenses?" asks the customer.

"They're $100," he says, watching again for the reaction, ". . . each."

Lewin's first job as a professional photographer was for a neighbor. "I charged $5," she says. "Then another neighbor saw the pictures and asked if I'd do her kids, too. 'Sure,' I told her. 'My standard fee is $25.' "

At the very first your fees will, in short, probably be very flexible, based largely on your own confidence (or lack of it), and your own assessment of what you think you can get. Both will no doubt rise as you acquire experience, and should keep rising. Nevertheless, as you

move more firmly into professional status you should establish a reasonably standardized pricing system that will be both competitive and profitable.

The fees for portrait work vary widely from one region to another, and the best way to get an idea of the range in your own community is by asking other local photographers either for estimates or for copies of their printed price lists. Even when you're a relatively inexperienced beginner, you'll probably want to set your fees somewhere around the middle—not at the bottom—of the local "going rate." The psychology behind this is that the average client doesn't want to deal with the cheapest professional talent available; most of us believe that you pay for what you get, and that low price is an indication of low quality.

In fact, some clients prefer to deal with a photographer who's famous or even notorious for high prices: it's a conspicuous-consumption status symbol, like caviar or a Rolls. A big-city "name" photographer (i.e., one who's well-known, published, fashionable) can sometimes charge $1000 or $2000 or more as a basic shooting fee.

For information about publications that list current "going rates" in various parts of the country, see the *Appendix*.

DEALING WITH THE CLIENTS

Many children's photographers, and especially those who operate out of their own studios, give their potential customers printed rate cards or job-order forms with long lists that specify the print sizes, types and mountings they have available, and the prices for each type in various quantities. Many also of-

Don't show private clients raw contact sheets or stacks of un-edited transparencies. Make the initial selections yourself. Present client with the best shots from a session.

fer several standard "package deals": an "economy" package with a specified number of poses and proofs or prints; a "standard" package, and a "prestige" package.

For the more informal shooting-on-location approach, you may not find this appropriate—especially at the beginning, when you're still unsure of what your customers want and what they're willing to pay.

But one way or another, you *do* have to give each customer or inquirer a clear, up-front statement about your basic charge, which in most cases should cover your expenses for at least two visits—one for shooting, one for selling—plus a minimum package of proofs or finished prints or both.

At first contact with the customer you could say, for example: "My basic fee is $150, Mrs. Jones, and half of that is payable at my first visit. That covers my time and expenses in coming to your home to shoot the pictures, and it will also give you twelve 3" x 5" (8 x 13 cm) prints of different views of your child, plus one framed 8" x 10" (20 x 25 cm) print. Of course, you'll also be able to order additional prints at an extra cost, in all kinds of sizes and frames and other display mountings, and I think you'll find that some of these are especially attractive gifts for relatives and friends."

It's in those additional prints that you'll have your chief source of profit ... and note that you can start selling them in advance, even before you shoot.

Order form and routine for sales. Have simple job-order forms printed up, describing your basic fee and terms.

There can be room at the bottom for additional print orders, and they should be printed in duplicate-plus-carbon form, so there'll be one copy for you, and one for the customer. Take the form with you on your first visit, and ask the customer to sign it. An order form minimizes the likelihood of misunderstandings later, and eases the process of getting your advance payment: you have something concrete to give in exchange for a check.

Packages and presentation. When you use the "continuum" shooting approach, you'll shoot many more views than you can sell. On your second visit, don't show the customer all the raw contacts and transparencies. One reason is that you'll probably be shooting on 35mm film, and most non-photographers can't understand the tiny images and visualize the enlarged (and maybe cropped) results. Another reason is that when you offer too many choices the customers can't make decisions. "Besides," says Lewin, "in any shoot there are bound to be some that are better than others. Edit them and give the customer the dozen or so best views to choose from, preferably in the form of 3" x 5" prints."

When you deliver the "minimum package" included in your basic charge, you can make your pitch for additional print sales. Be sure to bring along a few simple slide-in mounts. Most customers can't visualize the difference that framing or matting makes in the appeal of the final product. By showing them, you'll increase your sales of additional prints.

Keep in mind that even the most loving parent or relative has a limited

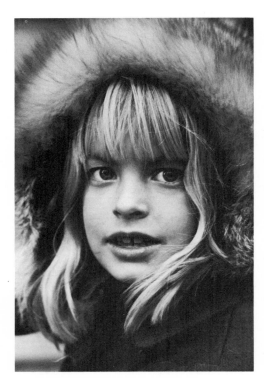

amount of space available for displaying photos in standard mounts and frames. So offer your customers some other attractive options, and show them samples. A few possibilities: wallet-sized prints; small purse-sized booklets, each with a dozen or so prints; larger, more elaborate "coffee table" books of prints; a collage of prints, mounted under Plexiglas; flip-over "custom" calendars, with a different view of the child for each month of the year. You can farm out the matting, mounting and framing work to a local shop, or learn to do it yourself. One excellent how-to-do-it manual is the *Amphoto Guide to Framing and Display* by Jan B. Miller.

Stay alert to new formats and finishing techniques. For example, all professional color labs can make prints on a material that looks like canvas, and some customers love the "oil painting" look. Make it a point to check frequently with labs and other suppliers about their latest possibilities.

Follow up. Go for follow-up sales, too. On the index card you keep for each customer, you'll naturally note these facts:
• Customer name, address, phone number, date of sale, age of child.
• Job number (the same as the number on your corresponding negative/transparency/contact file—see Chapter 3), and the identifying numbers of the frames chosen for the "minimum package" and additional prints. Plus information on the sizes and way in which the prints were sold.

In addition, you should note on the index card any information that may help you make additional sales. For ex-

Few private clients can visualize the difference that framing makes. To increase sales, bring a slide-in mount when you solicit additional print orders.

Left. Books of photos require minimal display space and are a good tool for multiple print sales. They can be purse sized for portability; large sized for coffee-table display.

Right. Christmas cards can boost your sales. You can offer formal printed cards or simple white cards with space for handwritten messages.

ample, the name and age of the child you photographed; the names, ages, and birthdays of other kids in the family; plus anything you've been able to glean about the hobbies or interests, special likes or dislikes of the child and family.

Some people like to keep a continuing photo record of their children—an excellent source of follow-up income. So, it is worth taking the trouble to call or write to the client when a birthday, graduation or some other special event is coming up. Another prime time for follow-up calls is in the early fall, when most families start thinking about Christmas gifts and cards.

What you sell. And finally, when you work with private clients keep in mind that you're selling prints only. You own the negatives, and some photographers try to make that point very clear by stamping the back of every print with a line that says: "Reproduction rights owned exclusively by (photographer's name)."

To protect the right-to-privacy of your private clients, it's also understood that you won't allow reproduction of any photos you've taken of their children without getting their permission and a model release.

And, as your negative files grow in quantity and improve in quality, you may need that permission from time to time—because your best shots for private clients can become the basis for your expansion to other areas of the profession.

Making the Move to Commercial Photography

Why would you want to make the move?

A. Because selling to editorial and advertising clients produces additional income and professional stature. For those who make it, it's also the source of the really big money in professional photography.

Q. When are you ready to make the move?

A. Whenever your work is good enough to be competitive in the marketplace. Maybe right now.

At the outset, it's important to realize that there is a substantial difference between doing editorial and advertising work on assignment and doing it "on spec"—that is, without having had it specifically assigned or otherwise solicited by the client. Some photographers (including Elyse Lewin) are able to make a quick and direct transition from private clients to editorial assignments. But it's practically impossible to get advertising assignments—building up to the territory of a six-digit income—unless you've first made some sales to publications for editorial use (whether you did them on spec or on assignment) or have submitted and sold unsolicited "stock" photos for advertising use. That's why most photographers (including Lewin) start out by trying to make at least some sales, and in many cases their first sales to non-private customers, by submitting unsolicited material to potential editorial and advertising clients.

But before you make any moves in editorial or advertising directions, you need to know about the two instruments designed to protect you in the world of commercial photography: model releases and copyrights.

WHAT YOU SHOULD KNOW ABOUT MODEL RELEASES

Using a picture of someone in an ad, on a calendar, on a greeting card, or in any other commercial way is an invasion of privacy unless the person has given you permission for that kind of use. Even selling somebody's photo for a magazine layout or a book illustration can also get you into the invasion-of-privacy thickets. Suppose, for example, that you sell a photo of some mischievous-looking youngster

Timing is important when making submissions to magazines. The photo shown here became part of layout on Christmas cookies.

to a publication which then (with or without your prior knowledge) uses it to illustrate an article about juvenile vandalism. Could the parents sue the publisher? Or you? Yes, possibly.

For reasons like these, releases are always required for advertising and other commercial use, and often required for editorial use. To cover yourself, you should have a signed model release in your files for every photo you submit to outside markets. To be sure you'll know which release goes with which images, number the releases to correspond with the numbers used in your negative/transparency filing system. Here's the wording of a typical release form:

Many photos are timeless enough to be salable year after year, which is one reason that some photographers use Roman numerals for copyright dates. *(Right and overleaf.)*

RELEASE

In consideration of $_____, receipt of which is acknowledged, I, _____, do hereby give _____(your name)_____ and his/her assigns, licensees, and legal representatives the irrevocable right to use my picture, photograph, or portrait in all forms and media and in all manners, for advertising, trade, or any other lawful purposes, in conjunction with my own name or a fictitious name. I waive any right to inspect or approve the finished product or the advertising copy or other written copy that may be created or used in connection therewith. I have read this release and am fully familiar with its contents.

Signed:_____

Witness:_____ Address:_____

Address:_____ Date:_____

CONSENT

I am the parent and guardian of the minor named above and have the legal authority to approve and execute the above release.

Signed:_____

Witness:_____ Address:_____

Address:_____ Date:_____

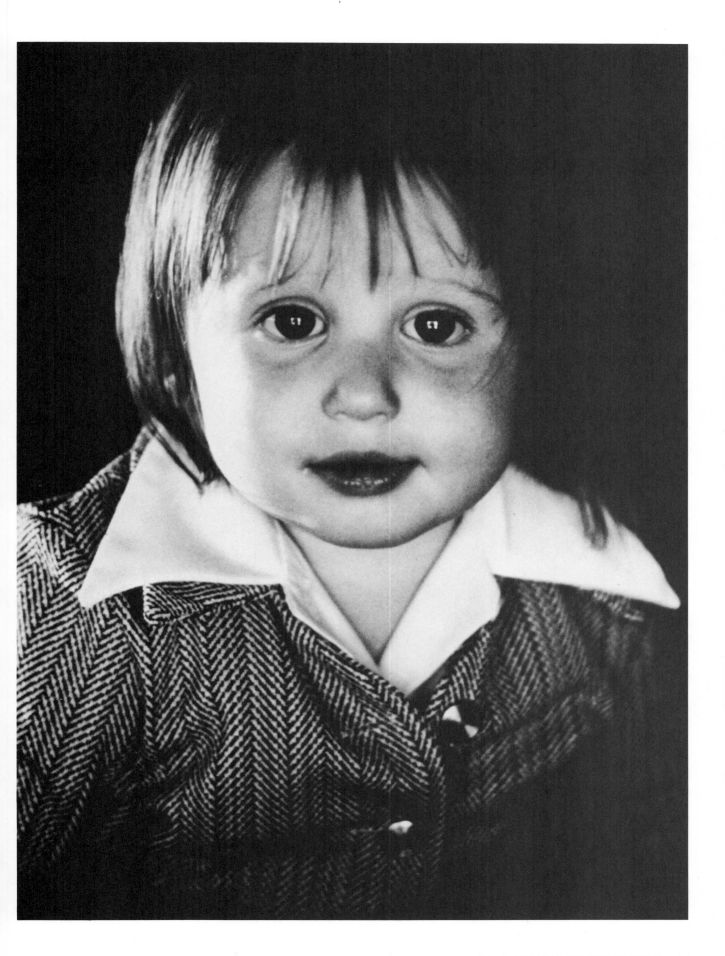

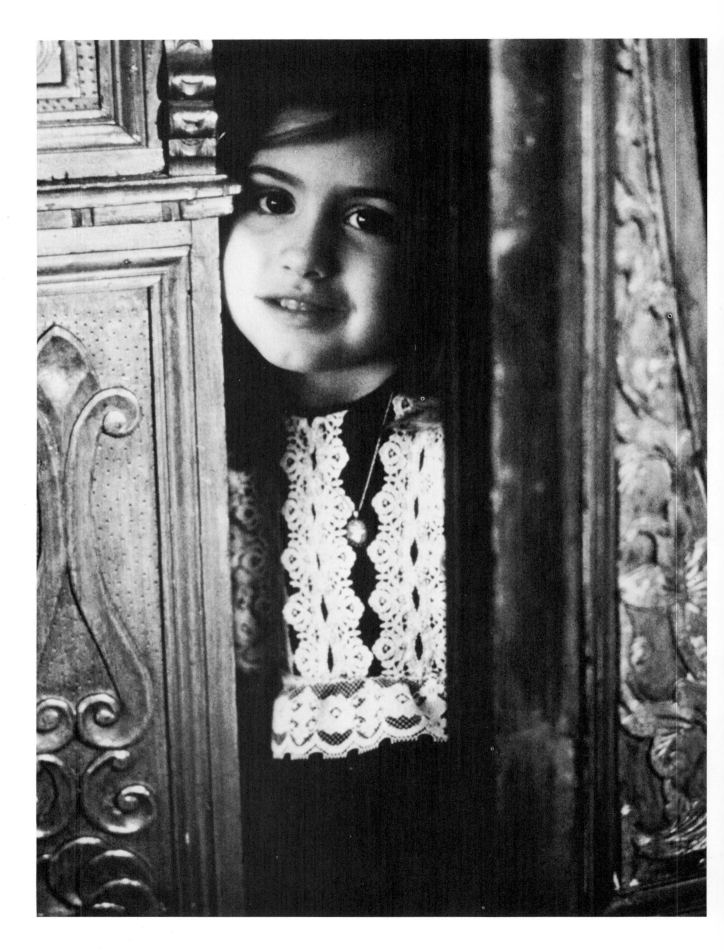

When working with adult subjects, the first paragraph should include an additional line that says, "I am of full age." When you're working with kids, it's the *Consent* portion of the release that's crucial. The signature of a witness isn't essential but it's helpful; and the "consideration" can be a token amount, even $1.

One more note: you don't need releases when you take pictures of bystanders or participants at a public event, as long as later use of the photos is related to the event. For instance, if you get a picture of a group of kids at a baseball game, it's all right to use it to illustrate a magazine article about sports. But suppose that same photo is used in an advertising campaign for Koogan's Kotton Kandy. That's a purpose *unrelated* to the event, and you'd need releases for anyone in the photo whose face is clearly recognizable.

WHAT YOU SHOULD KNOW ABOUT COPYRIGHTS

Most people find the concept of copyrights and copyright law awesome and a little scary. But you shouldn't. The copyright laws protect your rights and your ownership of the images you create every time you click a shutter, and they're designed to make that protection easily and instantly available.

What your rights are. Under the law, you have an inherent, built-in copyright for every picture you shoot. Essentially, it's the *right of reproduction* of that image. It's an abstract right, yours for your lifetime plus 50 years, and it's separate from any physical expression of the image. You can, for instance, sell prints or even negatives and still keep the copyright for yourself. In such cases, the buyer gets only the print or negative, but not the right to reproduce it. You can also sell your copyright, in whole or (preferably) in part, and we'll talk about that later. The only way you can lose your built-in copyright is by letting your work slide into the "public domain." This happens if you let it be publicly distributed without a notice that tells everyone who sees it that you own the right of reproduction.

Copyright notice. In order to *keep* your inherent copyright, you should stamp a copyright notice on every photo (in any form) that you sell or offer for sale. Have a rubber stamp made up that looks about like this:

Copyright (or ©) *Your Name*, 19__

That's your official notice, and you should use it on the border or back of each print, or on each transparency mount. The date you use can be either the year of first publication of the photo or the year you made the photograph.

When you sell or offer a photo for publication, try to have your own copyright notice used, either near the photo or on a credits page. You should do this even though the publication itself is covered by the author's or publisher's copyright. For this reason, your stamp could read:

Copyright (or ©) *Your Name*, 19__
An express condition of authorization to use this photograph is that the above copyright notice appear on all publicly distributed copies of the photograph.

Oddly enough, this notice protects your photo from falling into the public domain even if it is published without your copyright notice. Under the law, a copyright is valid as long as the buyer is aware of the "express condition" before using the photo. Some photographers use the longer stamp where there's room for it (such as on the back of prints) and the shorter stamp where there isn't (such as on transparency mounts). In the latter case, you can include your conditions on a submission letter, your invoice, or any other such communication with potential buyers.

Since many photos are timeless enough to be salable year after year, some photographers use Roman numerals for the copyright date. Because practically nobody can read Roman numerals at a glance (or even at several glances), a ten-year-old date on a transparency mount won't cause some editor or art director to assume the picture is stale and reject it without even looking at it.

Copyright registration. The notice procedures outlined above give you very good protection. But to nail down your rights in case someone tries to infringe on them, you should take one more step: *register* your copyrights with the U.S. Copyright Office.

When compared with most federal paperwork, copyright registration is simple. First you write to the U.S. Copyright Office, Library of Congress, Washington DC 20559, and ask them to send you the appropriate forms (they're free). In most cases you'll need *Form VA*; in some cases you'll also need *Form GR/CP*. You fill out the forms, enclose copies of your photos with a $10 filing fee, and send the package back to the Copyright Office. Because of the fee it's obviously uneconomical to register your copyrights one at a time. Fortunately, the regulations allow you to register them in big, once-a-year groups for a single $10 fee. The instructions that come with the forms tell you how to do it, and for additional information you can ask the Copyright Office to send you their free (and helpful) *Copyright Information Kit.*

Reproduction rights. Your copyrights are valuable not just because they protect you from having your work used without payment, but also because they're a little like land: they can be subdivided into many parts. And you should only sell the rights that the buyer needs.

Suppose, for example, that a magazine wants to buy eight of your previously-unpublished kids-at-Christmas photos for use in an upcoming December issue. You could sell all your rights to the pictures: you'd never be able to sell any of those photos again. Besides, it's probably unnecessary. The magazine may well be satisfied with limited rights—in this case, first-time North American (or serial) rights. By selling only that piece and holding on to the rest, you have the option to make additional sales of the same photos to other kinds of markets (such as book publishers or greeting card and poster manufacturers) and even to other magazines (elsewhere and later).

When you offer your photos for reproduction, try to predict which rights your potential client really needs.

A move to commercial work can start with photos originally shot for private clients as long as you have releases. This early Lewin portrait, for example, has magazine, calendar, and greeting-card potential.

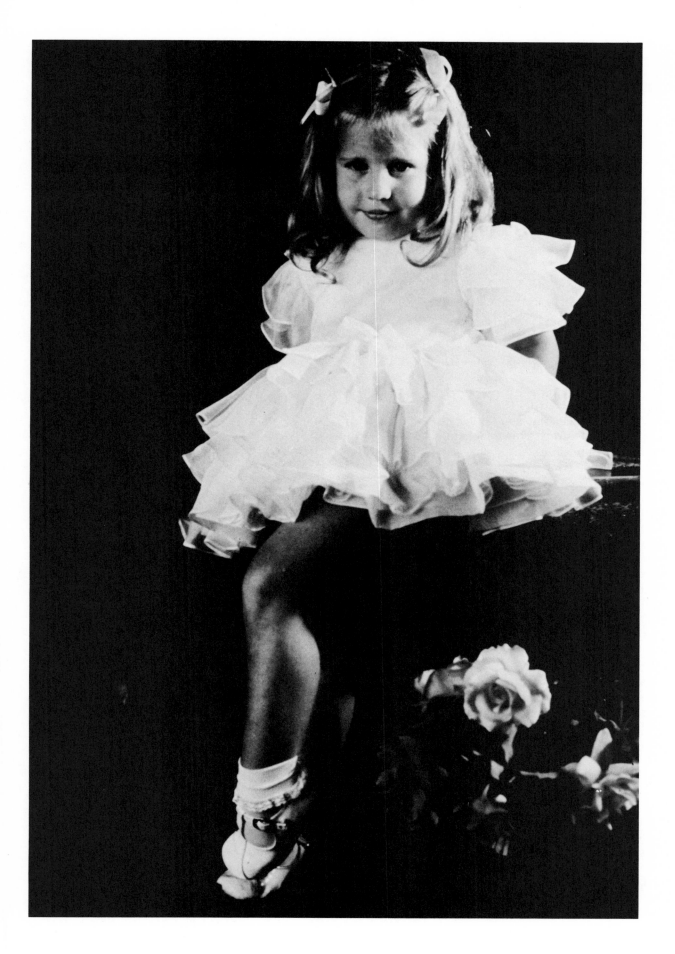

World, national, or local rights? First-time rights or forever rights? Rights for one medium, such as magazines or greeting cards, or for several? Then, either in your original submission or in later negotiations, give a clear definition—in writing—of which rights you propose to release.

SELLING TO MAGAZINES

Practically all magazines use photos of children at some time. A few magazines use them all the time—for covers, as illustrations for articles, and in special-feature photo essays.

Major magazines get most of their pictures from their own staff photographers or from tested and trusted freelancers working on assignment. But practically all magazines buy some photos that come in over the transom—photos submitted on speculation by photographers. Many smaller, special-interest, regional and trade publications get most of the photos they use (maybe even covers) from such stock submissions. Some major national magazines have even been known to assign a writer a story just because some unknown photographer sent them some terrific illustrations on a subject they hadn't thought of before.

It is a good idea to obtain a copy of a magazine's editorial calendar (available in most media kits) to see what special issues they are planning. You can then target your work to a particular issue and let them know which one when you submit a batch of photos.

You can get a birdseye view of the marketplace—quick rundowns on who buys what and estimates of what they pay—by going through some of the directories listed in the *Appendix*. But that kind of overview is just a starting point. Before you make contact you need a real feel for the publication. If you're not already very familiar with it, this means a research trip to the library for a look at current and recent issues. Among the points to consider are:

• Are the articles (and advertisements) aimed at kids, parents, women, or families? Or are they aimed at industries that produce goods (like toys) or services (like health care) involving children?

• Does the publication use lots of photos or just a few? Are they color, black-and-white, or both? Does the publication use photos only to illustrate articles or does it also contain photo essays?

• Are the photos first-rate in quality and thoughtfully laid out? Or are the photos back-of-the-file culls, indifferently displayed?

The answers will tell you how (or even whether) to make a submission.

As for the submission itself, there are two schools of thought on the best way to go:

The Write-in-Advance Approach. Photographers in this group advocate sending a letter before submitting any photos. Such a letter could go to the editor, the photo editor, or the features editor and might read like this:

Dear Ms. Jones:
Children often make unexpected and imaginative use of the toys their parents buy for them. I would like to submit to you a group of forty 35mm color trans-

With stock-shot submissions you never know what will sell. For example, a clown portrait might fit the requirements of a poster, calendar, or greeting-card buyer.

parencies that show children inventing such uses—some clever, some funny, all charming. The images would make an unusually appealing photo essay for readers of *Happy Families*, especially in the kind of format you used for the children's-fashions layout in your January issue.

I would like to offer you these transparencies for one-time editorial use at your usual rates. I look forward to hearing from you soon.

Sincerely,

A letter like this gives you the opportunity to sell an idea, your photos, and your understanding of the magazine's needs. It also primes the prospective client—although the usual positive response to this kind of letter says merely that they'd like to "see" your photos, which isn't the same as promising to buy them. Still, a letter from the magazine gives you an important edge. Your submission is no longer "unsolicited," and you have some legal recourse if the magazine loses, damages, or misplaces your transparencies.

Note that the letter offers many more images than the magazine would use even in a full-scale photo spread; that's because editors and art directors want the option of making selections.

The Give-'em-Something-to-Look-at Approach. "Photographers sell images, not words. They should show prospective buyers images, not words."

So says a photographer who advocates sending photos in your very first contact with a potential client, in spite of the added expense and risk.

Both of which are considerable. An

editor who receives totally unsolicited material has the right to file it in the wastebasket (though most won't). Therefore you need to take a few steps to minimize risks and costs and to increase the odds that your submission will be looked at with interest.

Theme. Though some publications use random photos of children for covers or article illustrations, most tend to be more interested in groups of images that express some kind of editorial idea, as in the sample letter above. When you submit unsolicited photos, try to connect them to a theme, and organize the work as intelligently and attractively as you can. Even though the publication may not buy all or any of your package, you may be remembered next time there's a need for stock shots or an assignment that your work would be appropriate for.

Duplicates. In any unsolicited submission, send duplicate transparencies, contact sheets or prints. Don't send original transparencies or negatives; you could lose them forever, with no recourse. (Note: Any time you're asked to send originals, ship them by insured, registered mail, air freight or UPS.)

Cover letter. Enclose a cover letter much like the one above, except that your second sentence will say, "I am hereby submitting to you a group . . . etc." Be sure all the images you send are marked with the same numbers you're using in your negative/transparency files and on corresponding index cards; it's important for your business to know exactly where everything is all the time. List the numbers of the images at the bottom of your letter after the word *Enclosures:*

Packing. Put everything you send in the appropriate envelopes, sleeves, or other containers. Include a stamped, self-addressed envelope and a stiffener (cardboard, corrugated board, or Styrofoam) to protect the contents of the package.

STOCK SUBMISSIONS TO OTHER MARKETS

Ever wonder where the firms that publish calendars, greeting cards, album covers, posters, and T-shirts, get the images they use? Mostly from stock submissions, that's where.

These and similar markets are often overlooked by beginning professionals, and that's too bad, because they're big, varied and relatively easy to hit. Unlike magazines, these markets tend to use individual shots only, and there's no need for an editorial theme. You just send them photos that are cute, funny, appealing, striking, or just plain beautiful. You never know in advance what will score.

To submit to these markets, check the directories listed in the *Appendix.* Pick firms that seem likely to be receptive to the type of photos you take, then follow the suggestions for submitting unsolicited material.

Some buyers pay continuing royalties on the images they buy and use. For the photographer who is looking ahead, that's very appealing indeed.

STOCK AGENTS

Stock submissions can be very profitable because they allow you to turn your unused file photos into income. But they can present a problem. Paperwork, and lots of it. In your files and on

Greeting cards are a top market for stock submissions or occasional assignment work. This imaginative scene of a child with an old-fashioned gent and a buggy was used by Hallmark.

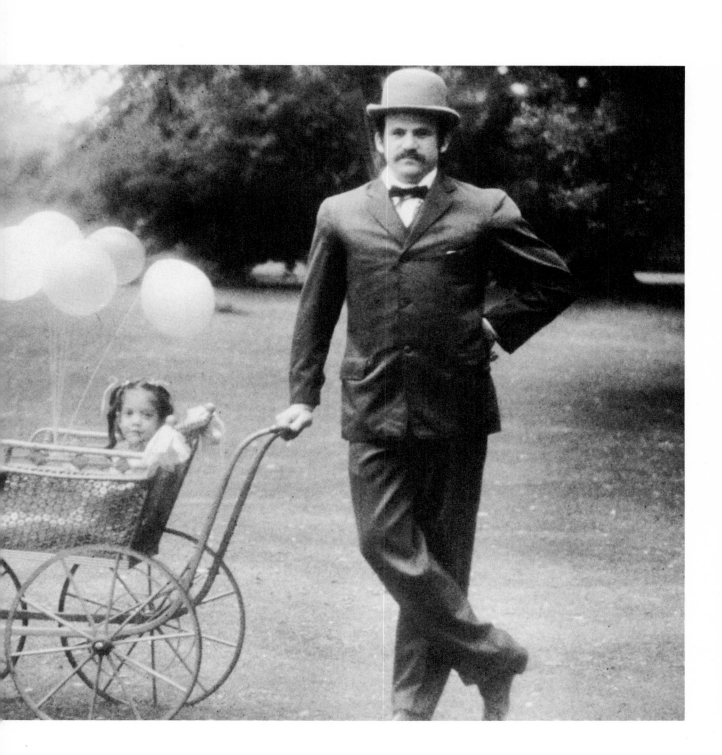

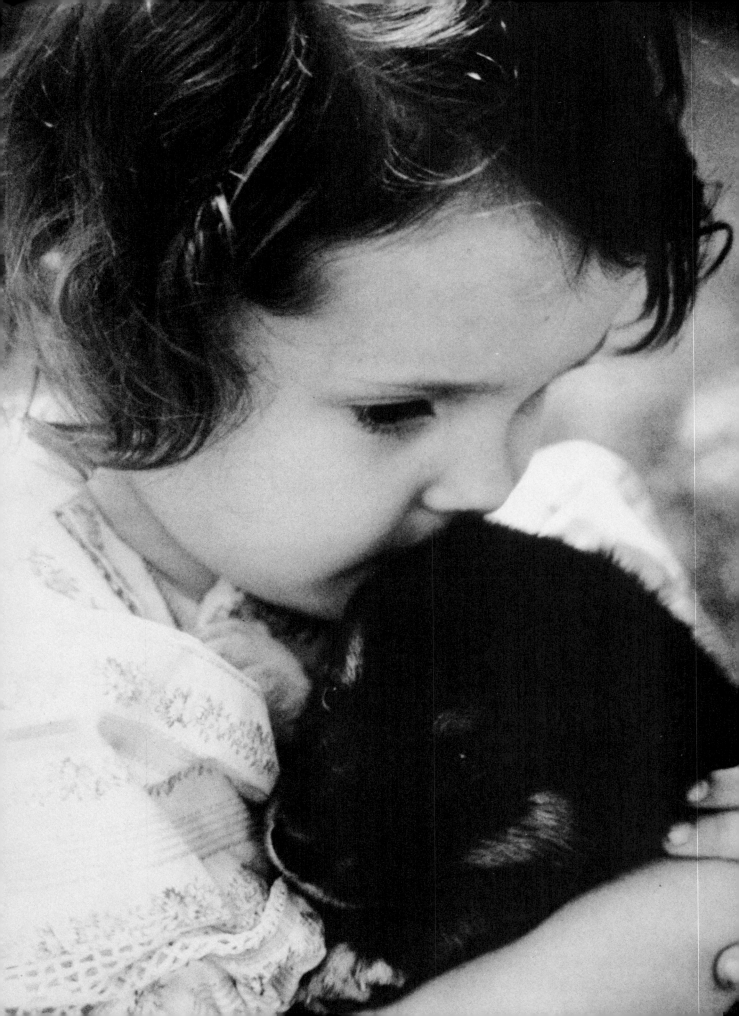

File photos sent to a stock agency can be unsold experimental shots or outtakes from editorial or commercial assignments. In the latter case, be sure your agreement with the client didn't negate your rights to outside sales. (See pages 104–107.)

your index cards, you must keep track of everything you submit; you must know what's out, what's been bought, what's been unused or even unacknowledged. In each case you have to know what rights have (or haven't) been bought; in many cases there are follow-up letters, statements, and invoices. You also have to keep potential markets interested by sending new material at more or less regular intervals. Clearly, the whole thing can put a serious dent in your time.

All of which explains why many photographers, including Elyse Lewin (who uses the Image Bank), turn large hunks of their photo files over to stock agents for marketing, instead of trying to handle the chores themselves. Stock agencies maintain huge libraries of stock photos, representing the work of hundreds and sometimes thousands of photographers. In exchange for usually 50 percent of the selling price, they handle the promotion, marketing, and paperwork of stock sales.

There are about 100 large stock agencies in the United States, and most of these are listed in one or another of the directories cited in the *Appendix*. Listed below are a few that may have more-than-average interest in photos of children. But *don't* send them (or any other stock agency) any photos until you've called them or written to find out if they're interested in taking you on.

The Image Bank, Inc.
633 Third Ave.
New York, NY 10017

Peter Arnold, Inc.
1500 Broadway
New York, NY 10036

Design Photographers International, Inc.
521 Madison Ave.
New York, NY 10022

Stock Photos Unlimited, Inc.
28 W. 38th St.
New York, NY 10018

Southern Stock Photos
PO Box 393726
Miami, FL 33169

After Image
6855 Santa Monica Blvd., Ste. 404
Los Angeles, CA 90038

Before you decide to work with a stock agency, you should consider certain things.

Most agencies won't be interested in representing you unless you can provide at least 500 good, potentially marketable photos. They'll also expect continual additions. But don't send *everything* in your files at once; the relationship might not work out as well as you hope. Also, it makes sense to hold onto your very best, most easily marketable images; the odds are you'll be able to sell those yourself, without the fifty-fifty split.

An agency will generally want exclusive rights to license reproduction of the material you send to them, for the period of your contract (usually three to five years). Since the copyrights still belong to you, everything you send should be marked with your copyright notice. Be aware also that you can "negotiate"

The album-cover market is often overlooked when stock submissions are being made. (See *Appendix* for directory of buyers.)

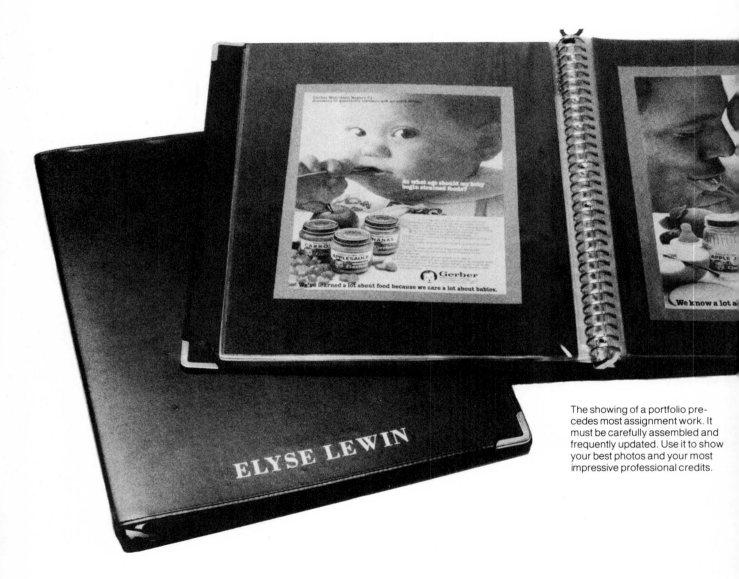

The showing of a portfolio precedes most assignment work. It must be carefully assembled and frequently updated. Use it to show your best photos and your most impressive professional credits.

an agency contract, just as you can negotiate when you sell rights to an individual client. As an example: an agency doesn't need "world" licensing rights unless it maintains a well-oiled marketing structure all over the world.

Agencies have different accounting procedures. So ask about each one's policy. At minimum, you should be provided with a quarterly statement of the sales they make for you and payment for those sales. The statement should tell who bought which photos, and how the photos will be used. Some agencies provide statements and payments on a monthly or bimonthly basis.

HOW TO CREATE
A SELLING PORTFOLIO

A portfolio is to the photographer what a sample case is to the Avon lady. It shows your product in its most seductive, most salable form, reveals your best professional credits to date, suggests what you can do if you're given the opportunity. To the prospective client, your portfolio is a graphic encapsulation of you, the professional.

The portfolio provides the most common bridge between selling on speculation or through stock submissions and working on assignment. Any time you make personal contact with a potential editorial or advertising client, you'll be expected to show a portfolio. Sometimes a potential out-of-the-area client will even ask you to send a portfolio. Clearly, your portfolio has to be put together carefully, refined, and improved constantly. It must also be changed sometimes to meet specific needs.

These questions are often asked about how to prepare a portfolio.

Q. What's the best form for a portfolio?

A. You can use a good-looking leather ring-binder or case, or a carousel slide projector for transparencies, or both. If you use a projector only (most photographers don't), everything you want to show including black-and-white photos will, of course, have to be copied onto slides.

Q. How extensive should it be?

A. Not very. An editor or art director may go through a thousand portfolios every year. Looking at yours shouldn't take more than ten minutes at most, and it's better to underdo than overdo. Most professionals agree that thirty or forty images are about the right number—and that a portfolio with ten knockout pieces is better than one with ten knockouts surrounded by thirty blahs.

Q. What should go into the portfolio?

A. The very best, most marketable work you've done to date, arranged and presented with as much impact and class as you can manage. Prints must be top quality—the best that you or your lab can produce. The portfolio should also include some tear sheets of your published work. And since a portfolio is something that gets thumbed and riffled through, both prints and tear sheets should be protected. One way to do it is by sliding them between plastic sheets. A better way (since loose plastic tends to produce glare that interferes with the image) is to have them laminated. This is a fairly inexpensive process that bonds the piece tightly between two sheets of plastic.

Remember also that your portfolio should be flexible and adjustable. Although some of the photos you use in it may be so sensational and appealing that they'll make up the core of what you'll want to show every time, others should be changed to match the needs of each prospect. You wouldn't, for example, show misty, moody images to a toy advertiser who's going to be interested in cheery-faced moppets and bright colors, in razor-sharp focus to show every last detail of the product.

In many cases, especially when you're a newcomer to the commercial markets, the need to show appropriate images means you'll have to set up and shoot specifically for your portfolio. But it's worth it. Your portfolio is your most important selling tool.

OTHER PROMOTION
One of the conventions of the photo business, especially in the big and ferociously competitive market areas such as New York and Los Angeles, is that after showing a portfolio, the photographer leaves, or mails, a "drop-off": an illustrated postcard, poster or brochure that gives the potential client a visual reminder of the photographer's style . . . and existence. The same kind of printed piece can be the core of a continuing direct-mail promotional program. Many well-paid photographers send reminder mailers to potential buyers once or twice a year, or sometimes even once a month, and follow them up with phone calls.

Postcards or other "self-contained" mailers (that is, pieces that don't have to be put into envelopes) work especially well for this kind of promotion,

and it's sometimes possible to work out a low-cost production deal with a good local designer/printer who, like you, hopes to catch the eyes of editorial and ad-agency clients. In exchange for giving the printer a credit line, you may be able to get low rates for production of the mailer. But when you're doing promotion, cost shouldn't be number-one in your mind. As noted earlier, anything that displays your name and your work should be of the highest quality possible. It's better to distribute nothing than something second-rate.

Many photographers who aim at the juicy, top-money national markets also place ads in trade publications that go to ad-agency art directors and other photo-buying bigwigs. Some of these publications are listed in the *Appendix.*

WHEN DO YOU NEED A REP?
"I hate to sell myself and I'm not much good at self-congratulation. It's a pleasure to have somebody out there showing my portfolio, telling the clients I'm terrific, and that I'll do the greatest job for them that can conceivably be done. Besides, I'm a photographer and a busy one. I need to spend my time shooting, not getting assignments or keeping track of billings."

So says Elyse Lewin when you ask her why she has a full-time, exclusive "assignment representative."

A rep is an agent who works with you closely and personally. Unlike the stock agencies, a rep has only a few clients (or even one, as in Lewin's case); not a hundred or a thousand. And unlike stock agencies, the rep's main job isn't selling your file photos but getting you first-rate editorial and advertising assign-

A promotional piece like this one can be used as a mailer to potential advertising and editorial clients or as a drop-off after you've shown a portfolio.

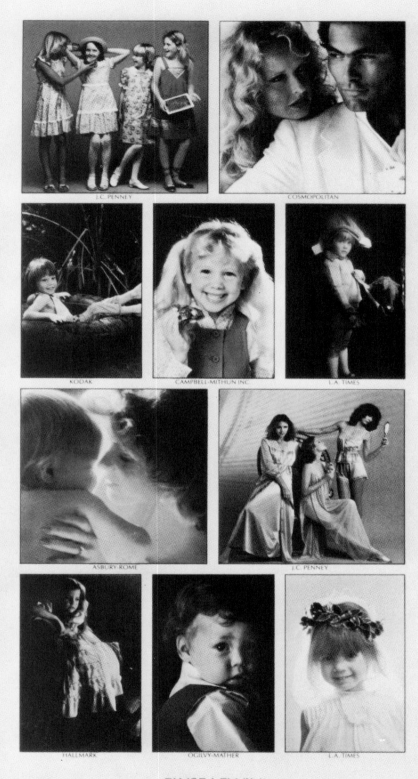

ELYSE LEWIN
820 N. FAIRFAX, LOS ANGELES, CALIFORNIA 90046
REPRESENTED BY VALERIE EVE LONDON
(213) 655-4214

ments, new and richer clients, bigger and better money.

Although contract terms vary widely, the average rep earns a 25 percent commission on the work you get through those efforts. The rep may also earn 10–25 percent on everything else you sell, including sales made by stock agencies or to accounts you had before the rep came on the scene. In some cases, a photographer may have one rep in one of the major market cities, such as Los Angeles, and another in another hot market, such as New York. Normally the rep will be your exclusive agent in that territory.

And when do you need a rep? Well, not at the beginning of your commercial career. It's much better to get some selling experience on your own, and at least a few commercial assignments, before you start working with a rep. You need a rep when you need and can handle more and better assignments, and when the rep's services will more than justify the 25 percent commission.

"And whether you like it or not," says Lewin, "there's another point that counts. The fact is there's a certain cachet to having a rep. When you're showing your own portfolio to top-money clients, they may think, 'This photographer is just a beginner, not big enough or important enough to have a rep.' Art directors feel safer, more secure giving assignments to 'top' photographers ... which translates, at least partially, as photographers busy enough and prosperous enough to retain a rep."

When the time comes for finding a rep, start with the information sources listed in the *Appendix,* and move slowly

enough to find someone who's really right for you: a rep who will work hard for you but won't overbook you beyond your ability (and desire) to deliver. Someone who is fully aware of and in tune with your professional aims.

WORKING ON ASSIGNMENT
Working on assignment changes your work habits, your pace, in fact, your whole approach to the profession. Instead of selling what's in your files or what you shoot on speculation, you commit yourself to filling the specific needs of an editorial or advertising client.

Working on assignment even has an effect on your paperwork. In many cases, the assignment will involve expenses for such things as travel, assistants, materials, models, props, and sets. And it's customary to bill the client for these. Therefore, for each assignment you should keep a large "job envelope," into which you put all receipts and other evidence of your expenses, so you can provide an itemized bill later. (When expenses are going to be considerable, by the way, it's standard procedure to get an advance payment from the client.)

In terms of what you're expected to produce, assignments can be very loose, very precise, or somewhere in between. At one end of the spectrum there's the assignment that gives you nearly total creative autonomy. For example, an editor might say "give us a nice, springy-looking cover for the Easter issue. Maybe something with a kid and flowers or some small animal." The options are all yours. You choose the background, the model and the narrative

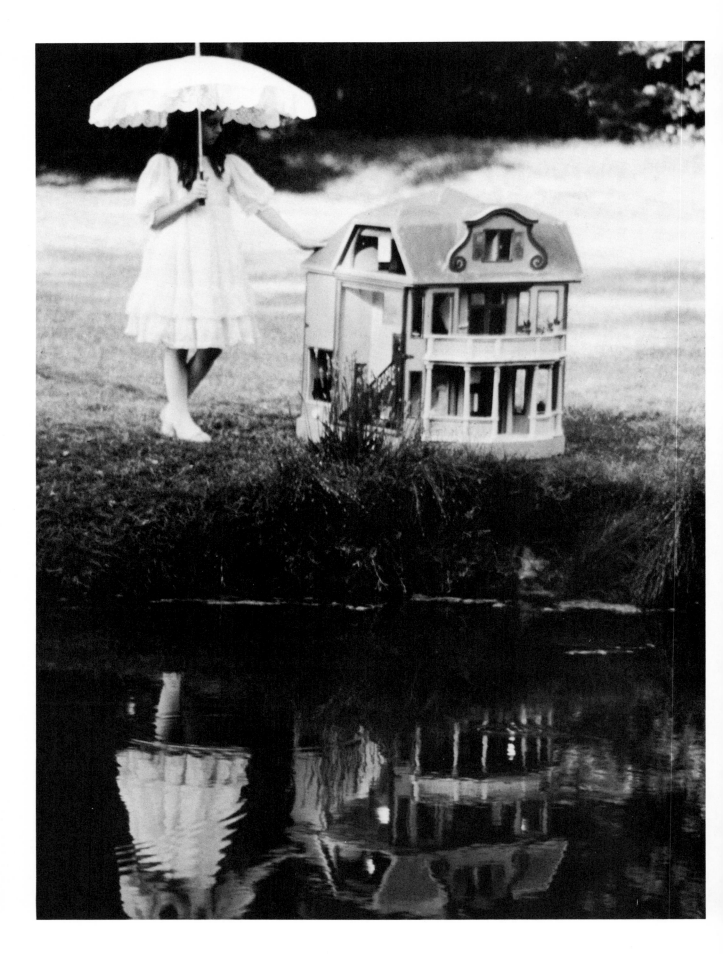

Some editorial assignments offer
creative autonomy—an editor sug-
gests a topic but leaves the details
to you. But don't expect such lee-
way until you've earned it. The two
of the girl with the flowers were
from the same shooting.

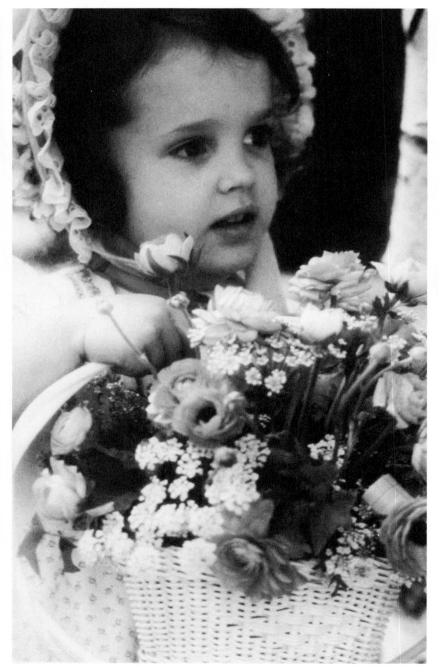

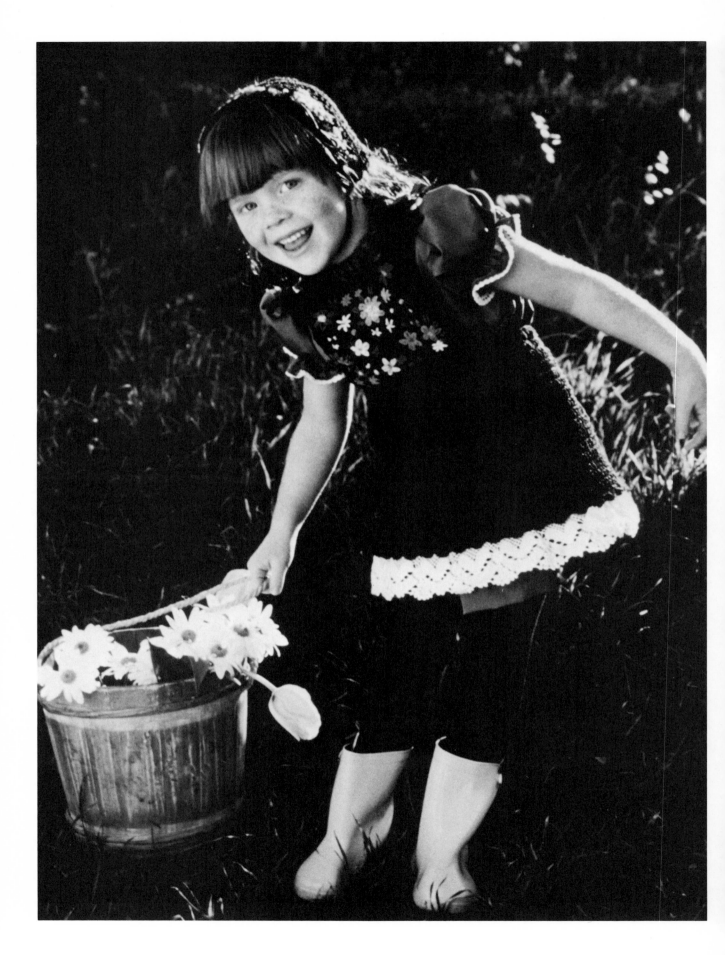

theme—the story that the picture will tell, even the feeling (joy, nostalgia, warmth) it will evoke in the viewer. This kind of open assignment is likely to come only after buyers are very familiar with your work and have full confidence in your judgment, your taste, and your craftsmanship.

There are editorial assignments in which you provide illustrations for a specified theme—anything from fall fashions for children to "a day in nursery school." The editor sets the parameters within which you'll shoot, and may set specific requirements for individual shots. For example: "We'll want a group shot with plenty of bright colors for the lead photo."

At the other end of the spectrum are the very precise assignments. Most advertising assignments are this way. The client (usually represented by the ad agency art director or account executive) typically knows exactly what they want in terms of the model, background, product display and even specific pose. Even when the image is supposed to have a narrative feel to it, the product must generally be shown with pinpoint clarity, the kind that demands total control of lighting, background, and model. And on the day of an advertising "shoot," you'll usually be working with a small army of high-priced talent: so you must be fully prepared to use it quickly and efficiently.

So far this book has given only glancing attention to the advertising area of professional photography. That's because it deserves and gets special attention in a chapter of its own (Chapter 7). Advertising work (and upper-echelon editorial work, which often has similar requirements) isn't just the best-paid field in the profession. It's also the most demanding in terms of skill, technique, and organization.

And while everything else we've talked about can usually be handled from a home-based operation, with a relatively low investment in space and equipment, the precision and organization required for advertising assignments almost always demand that you establish a studio.

Setting up a Studio

THE MAIN REASON to set up a studio is so you can gain total control of space, backgrounds, and especially lighting. Another important reason is so that you can accommodate the assistants and technicians involved in a high-budget commercial "shoot." You'll also need space for your clients and their representatives, for your own paperwork, and, of course, for the young models (and their accompanying retinue).

Elyse Lewin's Hollywood studio meets all those needs and then some. When you plan your own studio, you may want to incorporate or modify some of these basic design strategies.

Lighting. Advertising photography often demands razor-sharp focus and precise definition of the background as well as the foreground. To achieve that, Lewin's in-studio shooting technique is a reversal of the technique she uses on less formal assignments. Instead of shooting with a large aperture and a high shutter speed, which will stop the action but cause the background to be out-of-focus, she shoots at a small aperture that gives great depth of field so the details will be clear from here to infinity. And to compensate for the camera's decreased light-gathering ability, her studio has been made into a huge reflector.

Everything is painted white—the floor; walls; and high, sloping cathedral-like ceiling. To increase the available natural-light she uses strobe heads contained in big, light-diffusing boxes: one 4 x 4 ft (1.2 x 1.2m) overhead box on a boom, and a tall 4 × 8 ft (1.2 x 3.5m) unit that can be rolled around as required. To soften the light further into the warm, "natural" effect that characterizes Lewin images, she uses big light-diffusing umbrellas and filters as required.

Space divisions. As you can see from the floor plan, the shooting space is the most important part of the Lewin studio. At the right front corner of the 30 x 50 ft (9.1 x 15.2m) building there's a reception or conference-type office; behind it, extending to the rear wall, a darkroom and processing space. The strip of space on the left-hand side has a business office in front, and a dressing room and kitchen at the rear. Models can change, food stylists can prepare products for shooting, technicians can process, clients can confer, and Lewin's rep can handle the phone

A white, bright interior acts as a huge reflector, providing a controlled facsimile of natural outdoor light. A big shooting space allows plenty of room for props and complex sets.

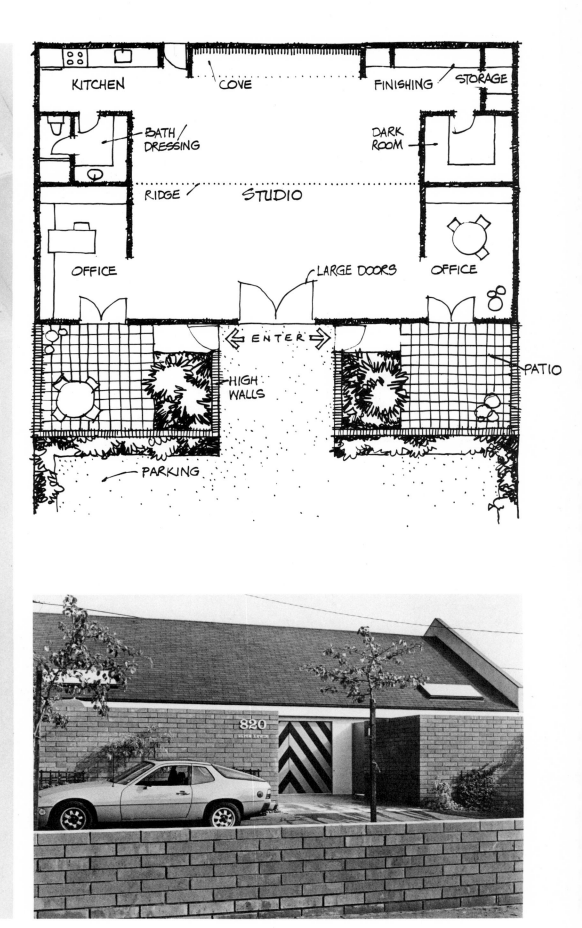

Left. A kitchen is not only helpful to food stylists, but it is also a useful place for keeping snacks during a commercial shoot.

Right. A good floor plan puts a big shooting space in the center. Peripheral space is divided into areas for other activities. Also note that the rear studio wall is coved for a seamless background. Drawing by Lester Wertheimer.

Below. Lewin's Hollywood studio is chic, well-located, and impressive in decor. More importantly, its interior space is shrewdly designed for maximum control of the lighting, the backgrounds, and the models.

In this studio there are two offices, one on each side of the shooting space. Both are brightened by skylights and comfortably furnished for conferences.

without impinging on the main activity of the studio: photographing.

The studio space itself is the hub. In addition to being white and bright, it's bare enough and big enough to contain the complex stage sets often required for advertising photography. The need for control and precision often makes it impossible to rely on real backgrounds.

One other detail is worth noting. The back wall of the shooting area is a smooth curve that eliminates visible join lines between wall and floor, wall and ceiling. This makes it easy to produce the clean, no-lines background often required in advertising shots. To get the same effect in less carefully planned surroundings, photographers and their assistants have to wrestle with unwieldy rolls of seamless paper that can be hung and spread to mask the background joins.

Location and cost. In addition to being extremely functional, Lewin's studio is well located, chic in finish and decor, and very impressive to clients—all of which is nice but not essential. It was also designed from the ground up to fit her specific needs—which is also nice, but not essential. Though the Lewin layout or a variation of it may be an ideal to aim for, you should be able to meet most of your needs by carefully converting a store, a warehouse, or even a barn into a studio.

You can also take over an existing studio, fully equipped. As with most other businesses for sale the purchase price is likely to depend less on the equipment and inventory that goes with the space, but on the annual gross sales enjoyed (or suffered) by the owner. In some areas—mainly in small towns—you can buy a fully equipped studio for as little as $12,000 to $15,000. In other areas that amount won't even cover a down payment. For example, a fully-equipped studio that grosses $200,000 per year in sales, might sell for $155,000. If that same studio had grossed only $40,000, it might sell for $28,000 or $30,000.

Hiring studio space. In all big cities and many small ones, fully equipped studio space is available for rent on an hourly, daily or weekly basis. Many photographers take advantage of such facilities before they invest in a studio of their own. This is an intelligent way to do things. In the process of using other people's studio space, you'll get a much clearer idea of what you do and don't want in your own.

ACTIVEWEA

Are you just going to sit there and watch our lir
move, or do you want in on the action?

Dontcha
LUV·IT

Warm-up suits, jumpsuits, ten
skirt, jackets, shorts and tops a
in sizes 4-6x, 7-14 and Preteer

The Fast Lane: Shooting Advertising Assignments

IN VERMONT there's a photographer who produces all the photographs for the mail-order catalog of a local toy manufacturer. In a Southwest vacation area, a children's photographer supplements her income from portraits and stock sales by illustrating brochures for family resorts and campsites.

In short, advertising assignments based on your expertise with children can happen anywhere—wherever there's a store that needs newspaper ads or seasonal catalogs, wherever there's a firm that provides goods or services aimed at children or family markets.

But the hot spots for ad assignments are, of course, the great media centers that serve the major national advertisers: New York, Los Angeles, Chicago, and most recently, Atlanta and Houston. That's where the rewards are the richest and competition the toughest. Success demands the most you can muster in craftsmanship and organization.

"It's life in the fast lane," says Lewin. "The stakes are very high, the time is tight, the pressure enormous."

An ad layout for children's fashions, for instance, may call for an intricate set and five or six young models, each of whom is earning $100 an hour. The shot may also require an army of high-priced people on hand who never get into camera range. And the pressure is compounded by the fact that child models, like other kids, are at their best only in the first half-hour of shooting; infants in just the first ten minutes.

PLANNING AHEAD

For the typical advertising assignment two people operate at the top of the decision-making hierarchy: the photographer and the ad agency art director. The agency may have a clear and sometimes rigid idea of what the final image should be. And often that idea is based on direct instruction from the client.

"The agency's art department may hand me a rough sketch of what's required," says Lewin, "and I can either copy it or try to improve on it. I try to improve on it. I want the final image to be beyond the client's expectations. When he sees it, I

Advertising photos must often be as precise and stylized as the logos and other printed material that accompany them. Even with these requirements, Lewin's work has life in it. (See pages 126–129.)

want him to say 'Wow!' "

One crucial point to remember, she points out, is that advertising photos have a single purpose: to help advertisers sell their products or services. "I ask myself what they want to convey in the ad. Is the baby supposed to be happier, healthier, more satisfied because he eats the baby food? Is the child supposed to be more alert and more fun because he or she plays with the toy? Or is the toy supposed to improve the child's coordination or make him or her a better learner?"

To a large extent the success with which the concept is conveyed will depend on the choice of the model. And Lewin's colleagues agree that her ability to cast the right models for the message is extraordinary.

"I'm interested in more than just cuteness or good looks," she says. "The way a child moves and responds is even more important, and that's what I try to be particularly sensitive to. Some youngsters have an innate charm of movement, and some kids, like some adults, will give you more. When I find good models I often stay with them for years."

But even though child models may make unpredictably charming, better-than-expected responses on camera, you must know in advance what image you're looking for in an advertising assignment, and exactly how you'll go about getting it.

"Every decision you make is important," Lewin says. "The clothes you choose, the props, the attitude, the body and facial responses you hope to evoke, and how you're going to get them. You ask yourself, 'How am I go-

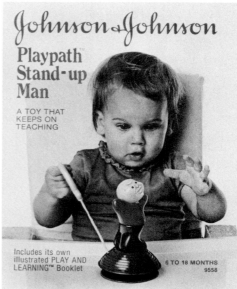

Johnson & Johnson

Playpath™ Stand-up Man

A TOY THAT
KEEPS ON
TEACHING

Includes its own
illustrated PLAY AND
LEARNING™ Booklet

6 TO 18 MONTHS
9558

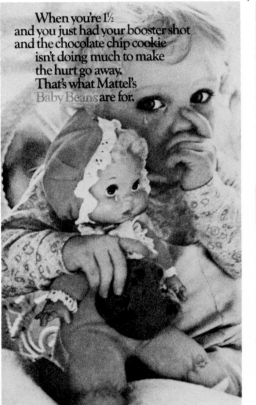

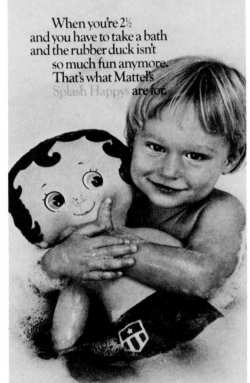

These images show the photographer's striking ability to cast and control young models. Note that the physical appearance and facial expressions mirror those of the products. Also, here is an additional shot from the same shooting. It attests to the fact that many photos must be taken to find the ultimate one.

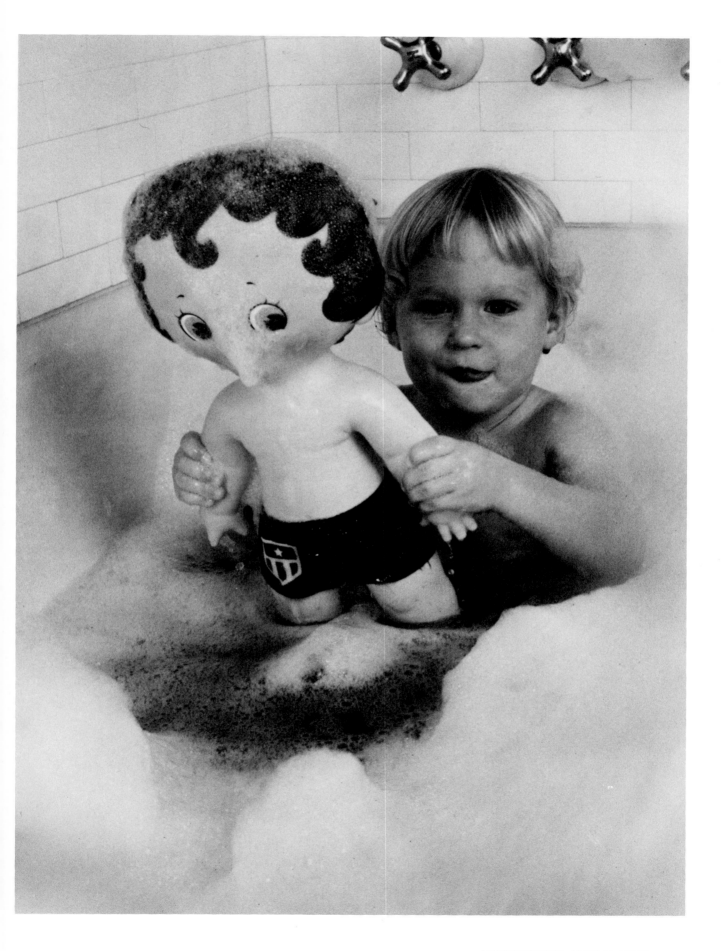

When you're 2½
and you've just been tucked into bed
and you're wishing that falling asleep
weren't so lonesome.
That's what Mattel's Drowsy is for.

ing to light this for the effect I need? Where am I going to go to get the right angles?' On the day of the shoot, you certainly can't expect all those high-priced people to stand around while you experiment with different poses or lighting effects. And that has to be thought out and tested in advance."

Lewin usually does that kind of experimenting the day before a shoot. "I'll use stand-ins for models, work with different lighting setups and camera angles, and test the whole thing out so I'm sure it works. And that night I'll go over it in my head again and again, trying to predict and forestall things that might go wrong, allow for all the contingencies."

You must also be sure in advance that all the technical elements will mesh so that when you're actually behind the camera you can concentrate on pose, movement, expression, response.

SHOOTING DAY

When you're on a full-fledged, high-budget advertising assignment, you're likely to be dealing with some or all of these people:

• The client and/or advertising-agency representatives, including the art director.

• Product stylists or food stylists whose special job is to make food products look good on film (sometimes with "cosmetics" that are downright unappetizing).

• Fashion stylists who see to it that clothing is unwrinkled and displayed to best effect on the model.

• Hair stylists and makeup people. ("When the models are kids," says

Child models, like other kids, are at their best only in the first half-hour of shooting. You must work quickly to get the shot that will make the ad a success. At right is a shot from the same shooting.

6. Finally, your Buster Brown salesperson will make sure the heel of the shoe hugs your child's heel and holds it in place.

The foot shouldn't wobble around and feel lost in space.

The point of all these points is that fit is more than just how it feels. Or how it looks. Fit is a whole system of checks and balances which make sure that

your child's shoes contribute as much balance and support as possible.

How do we know? Well, these little feet may only go back a few years. But Buster Brown's perfect fit goes back more than seventy-five years. No other brand of children's shoes can make this claim.

*The Buster Brown 6-Point Perfect Fit Check is yours FREE even if your children don't wear Buster Brown shoes. Bring your children in and see just how well their old shoes really do fit.

Buster Brown.

Brown Shoe Company. 8300 Maryland Avenue. St. Louis, Mo. 63105 • a member of Brown Group, Inc.

Lewin, "you insist that these experts do their thing with a very light touch. You want the kids to look human, not plastic.")

• Parents, model-agency representative, or maybe a social welfare worker. In some areas the latter is required to be on the scene whenever a child is being used as a paid professional model. The reason is to monitor the shoot and make sure there's no violation of any special rules and regulations that apply to youngsters. An example of such regulations is a strict limitation on the amount of time a child can spend under hot lights in some cases. This is why most commercial photographers use studio strobe units when they're working with children.

• Your own assistant, one or several. An assistant helps with changes in sets and lighting and keeps you supplied with film so there's no interruption of your flow or concentration when you're shooting. Sometimes an assistant can also help with models.

• Of course, last but not least the model or models.

In many advertising shots, the people are strictly secondary to the product. In an ad shot for food or toys, the model's pose, attitude, and expression may be as stylized as the product's logo. In a non-narrative fashion ad, what counts most is the precise display of every last pleat and tuck in the garment. But, it's characteristic of Lewin's talent and of the "Lewin look" that even when the requirements are super-rigid, she can still manage to inject warmth, naturalness and humanity into the final image.

And this, of course, is because she has a large endowment of what we identified early on as the prime requisite for success in child photography: she understands what makes children tick. Even in the high-pressure and often frantic environment of a commercial shoot, she knows how to bring out the magic.

How do you make a baby reach for a toy with real eagerness and delight?

"Well," says Lewin, "You find out from his mother that what he loves most in the world is pretzels. So you let him see you put a pretzel or two under the toy, then shoot when he grins and goes for it."

How do you get a baby to cry on cue?

"You put him down for a nap, then wake him. Every mother knows that babies almost always wake up from a short nap cranky and crying. You can just about lay odds on it."

And how do you get a group of eight-year-olds to interact naturally with each other in front of the camera?

"You try to keep up with the current kid fads and get them to talk and joke about what interests them—the Cookie Monster or Darth Vader or whatever. Or you suggest that the little boys kiss the little girls. That's almost sure to get them giggling and reacting. And if everything else fails, you get them to sing."

Then once you've captured what you need on film, you take great care to protect it. When Lewin finishes an advertising assignment, she sends the film to a processing laboratory in three separate batches, one-third of the film on three consecutive days, if time allows: "That way the whole take won't be lost if there's a wrong mixture of chemicals or some other accident in the lab."

Right. Natural grace is as important in models as an attractive appearance. Says Lewin, ''When I find good ones, I'll use them for years.''

Another sign of control is natural-looking interaction between a group of young models. Another shot from the same shooting captures a moment where the children were more aware of the camera.

New and exciting on the horizon, Calamity Jane® Girlswear in sizes 4-6X and 7-14. Bright, beautifully styled, related separates, designed with the spirit of today's girl.

The New Brand for Volume Fashion

Calamity Jane®

138

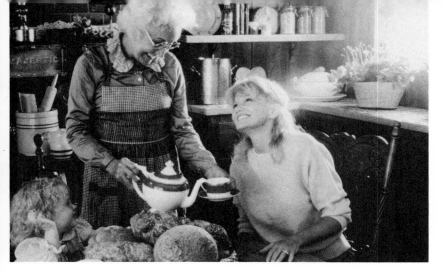

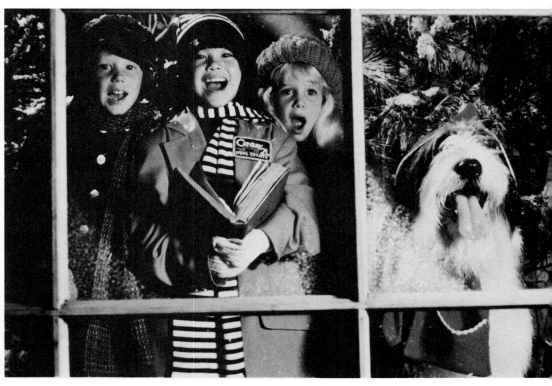

When Victoria was still a child and the British Empire stretched past all horizons, little girls throughout England spent most of their time (and much of Papa's money) in adding to their seemingly-endless collection of little porcelain miniatures.

Almost everything has changed since then.

Except little girls.

Planning is the key to success in the fast lane. Clothes, props, lighting, and expression must be carefully thought out . . . before the shooting.

Of course accidents like that don't happen often. But when you're running in the fast lane, you can't afford to take any chances.

NEGOTIATING AGREEMENTS

In advertising assignments, as in all other areas of professional work, some parts of the photographer-client relationship are fairly standard, others are very negotiable.

Fees. In a few cases you may be paid an agreed-upon amount per photograph used by the client. In most cases, though, you'll be paid a day rate for the assignment. Payment of that rate gives the advertiser specified usage rights to the photos that you take on the assignment. The agreement may specify a fee for one day or for a guaranteed number of days—and the rate, of course, is negotiable. It may be as little as $150 for a small local advertiser who's buying limited usage rights, or as much as $2500 (or more) for a major advertiser.

The high-end figure may sound like a lot of money, and it is. But it's important to realize that the money usually applies only to the actual days of shooting, not to the many days you may spend in preparation for the assignment. That's why many professionals try to negotiate additional fees (often half the day rate) for time spent in traveling, supervision of set-building, casting, or other preparation for a complicated assignment.

Some other questions ought to be considered in your negotiations and covered in your agreement with a client. For example, what happens if the client suddenly decides to cancel an assignment after you've already turned

down other bookings for the day? What happens if it rains on the day specified for an outdoor assignment? What if the client changes his or her mind about the layout after the shoot, and wants to reshoot the whole assignment? When the day rate is high and the deal is otherwise attractive, you may not want to quibble about such contingencies. But many professionals try to specify partial compensation (again, half the day rate is common) for such inconveniences as short-notice cancellations and reshoots.

Expenses. It's customary, though not inevitable, for the client to pay all the expenses involved in an assignment. Certainly when they will be substantial, the expenses should be clearly worked out in your agreement. Among the items usually included: cost of film and processing; cost of props and sets; fees to models, stylists, assistants and others whose services are required for the assignment; and any travel, transportation and location expenses.

If your agreement with the client includes an estimate of the expenses, it should also specify what happens if your actual expenses exceed the estimate. And on an assignment that involves heavy out-of-pocket expenses, it's usual for the client to give you a cash advance.

Usage. Unsophisticated clients—such as small-town merchandisers or manufacturers—may have trouble understanding that even though they're paying you an assignment fee and covering your expenses, you still own the rights to the images you shoot. You will transfer to them only the usage rights specified in your agreement. You may have

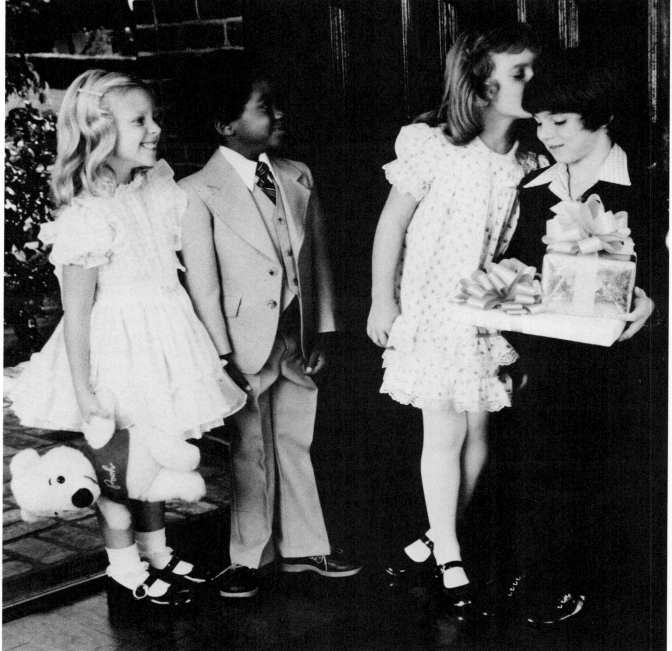

Another proof of Lewin's way with youngsters—the natural, spontaneous laughter of this group of young models. *Below* is a photo from the same shooting which captures a touching moment.

to explain to them that under the laws of copyright, the person who creates the work is the copyright owner and that's the way it is.

The usage rights you're transferring should be clearly defined in your agreement with the client. This can be done on the client's purchase order, on your invoice, or in a letter or note confirming your acceptance of the assignment. The letter could say, for example:

> Thank you for the assignment to shoot the photos for your new catalog. As we discussed, the shooting date will be August 20, my fee will be $400 plus expenses, and the photos are to be used for your catalog only.

When you sell limited rights, the original transparencies or negatives should be returned to you when the client has finished with them; and if the client decides to use the same images in some other medium, such as in a magazine or newspaper, you're entitled to more money.

In some cases—especially at the up-per end of the rate scales—a client may want all rights to the photos they select. They may even want all rights to all the images shot during the assignment. If you agree to sell those rights the client will keep the negatives and you have no further rights to the images: you can't, for example, use the "out-takes" (the photos not actually chosen for reproduction by the advertiser) as stock submissions, which can, of course, be a substantial source of additional income. Nevertheless, such an agreement is perfectly okay as long as you feel the compensation is adequate.

Clearly there is a lot of room for give-and-take in your negotiations with advertising clients. And just as clearly, in the beginning when an advertising assignment you get offers such fringe benefits as experience, credits and helpful additions to your portfolio, you'll undoubtedly be willing to make concessions on such things as rates and rights. But once you begin to feel at home in the fast lane, your concessions should lessen substantially.

HELLO

Elyse Lewin Photography 4423 Firmament Avenue Encino California 91316 (213) 788-1601

CHAPTER EIGHT

The Nuts and Bolts of Doing Business

SOME PHOTOGRAPHERS claim to have no head for business. A few even brag about their lack of business acumen. Maybe they believe this makes them seem more creative. What it really makes them seem is doomed to a permanent state of amateurism.

True, photography as a profession is one in which creativity plays an important part. But it's also a business. Until you can afford to turn your affairs over to an accountant, a manager, or a full-time rep, it's essential for you to understand and be able to handle the nitty-gritty details of starting and running a business.

CHOOSING A NAME AND LOGO

Most small businesses are born at a print shop, where the soon-to-be owner/manager takes the first official step towards being a professional: ordering business cards, letterhead stationery, and bill forms, all imprinted with a business name and logo. Since all these items will go to prospective and actual clients, they represent a modest but important form of promotion. And since you're in the business of graphic images, they should be simple but graphically appealing. If you can't design an attractive logo yourself, get help from a professional. Many print shops offer design services as part of a package.

Of course, in order to design your logo you must first decide on a business name. Today it is fashionable to have a cute, catchy name. But such fashions tend to fade swiftly. Simplicity is often more memorable and more effective. For years the name of Lewin's business was Elyse Lewin. Now it's Elyse Lewin Studio, Inc., and those simple and obvious choices have served her well.

Using your own name as your business name gives you a built-in form of promotion. It also gives you one small but very helpful shortcut through the red tape of licensing.

LICENSING AND OTHER RED TAPE

Looked at as a whole, the red tape involved in starting a small business can be enough to tighten the lips, whiten the knuckles, and dim the aspirations of the av-

The choice of simple business name and a distinctive logo, as shown on the mailers here, can launch you as a professional.

NUTS AND BOLTS OF DOING BUSINESS 145

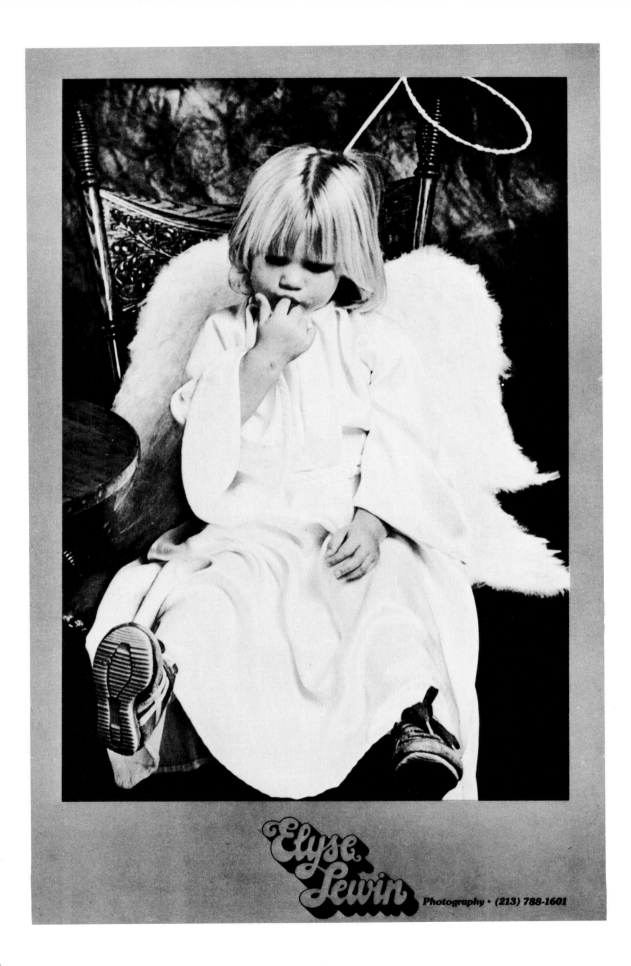

Elyse Lewin

Photography • (213) 788-1601

erage form-hating citizen. Dealt with bit by bit, it's unappealing but not overwhelming.

The requirements vary widely in different cities, counties and states, but in most areas you'll have to consider certain regulations and procedures.

Fictitious-name regulations. When you operate a business under any name but your own, your city, county, or state may demand that you register that name in a way that reveals that you, Jane or John Shooter, are also-known-as or doing-business-as Infant Images Co. at 241 Main Street. Registration usually involves a fee, and you may also have to publish the registration notice in the legal-notice classifieds of a local newspaper. Or you can bypass the problem by doing business under your own name.

Business licensing. For most cities and some counties, this is a simple and successful way for them to raise funds. In exchange for an annual fee, you get the "right" to do business but no other services at all. The fee is sometimes standard and sometimes variable, depending on your annual volume of sales. In some cities licenses are required only for retail stores, manufacturing firms, and commercial-district service firms. But in others, even a home-based professional is supposed to operate under license.

Special permits. Photographers rarely need special permits related to such concerns as public health, fire, and pollution. But as noted in Chapter 7, you may need to have a social welfare worker on hand when you're using children as paid models. To find out about the rules in your area, contact the city or county agency that monitors child health and welfare.

Sales tax permit and procedures. Practically all states (and many cities) charge and collect sales taxes. The transactions that are and aren't subject to sales tax vary with the jurisdictions. There are, however, general guidelines.
• When you sell a tangible product such as a print directly to a consumer, you usually must charge and collect sales tax.
• When you sell a tangible product to a wholesaler, retailer, or some other middleman, you usually don't have to charge and collect sales tax.
• When you sell only rights, such as the right to reproduce a photo, you usually don't have to charge and collect sales tax. But if that sale is tied to a physical object that won't be returned to you (such as a print or transparency) you then usually must charge and collect sales tax.
• When you sell services only, rather than products you probably don't have to charge and collect sales tax; but this is a gray area, so check your local regulations.

Given the above guidelines, the odds are that you'll have to charge and collect sales tax on at least some of your transactions which means you'll have to apply for a sales-tax permit. You can usually apply for such a permit from a state or city agency called something like Franchise Tax Board or Sales Tax Bureau. Some jurisdictions require a bond or advance deposit against soon-to-be-collected sales tax when you first apply for your permit. In exchange for that and any other fees, you get the permit plus a fringe benefit called a re-

sale number. A resale number is handy proof that you're a bona fide business person who's making sales to the public. This qualifies you to buy your materials, equipment and supplies at a professional discount and at wholesale and manufacturer's prices.

Zoning regulations. In most parts of the country you'll have no zoning problems as long as you operate as a quiet, home-based professional, working mainly on location for private or commercial accounts, doing only paperwork, darkroom chores and occasionally some shooting at home. But if you try to set up a full-scale studio at home, things could get sticky.

In most towns and cities, homes and apartments are in residential zones. In most towns and cities, studios are supposed to be in commercial zones. And zoning rules are often strictly enforced. So don't go to the expense of equipping a studio at home (or anywhere else) until you're sure the property has the appropriate zoning. Exceptions to zoning laws must be specifically approved by local planning or governing bodies, and such approval is usually difficult to get.

TYPES OF BUSINESS STRUCTURES
There are three major types of business structures, each with advantages and disadvantages.

Sole proprietorship. A sole proprietor is any person who conducts an unincorporated business for profit. It's simple in definition, simple in fact: a sole proprietorship is the easiest and least costly way to start and operate a business. And that's its main advantage. Except for the need to hack your way through the bureaucratic jungles de-scribed above (which you have to do with any kind of business structure), you face no starting-out complexities, no need to get involved with lawyers and contracts.

The disadvantage is that the business is *you*, and you're personally liable for all business debts. And because the law sees you and your business as a single entity, you're taxed on your total business income, whether or not you draw it out for personal use. And even though as a self-employed sole proprietor you get many more tax breaks than a salaried employee, you still can't take advantage of all the sheltering devices available to corporations and carefully constructed partnerships.

But these disadvantages apply only when your business starts making a lot of money, at which point you can switch to another type of structure. Until then, sole proprietorship is usually the best way to go.

Partnership. It's one of the truisms of business that you should take on a partner only when he or she can make a substantial contribution to the business: time, talent, facilities, or capital. When that's the case, a partnership can offer some significant tax benefits. In a partnership income-and-expense items may be distributed among the partners in a way that gives each of them the most beneficial tax results. For even further tax benefits, each partner can make deals with the entity: lend it money, lease or sell property or equipment to it, and so on.

The disadvantage, of course, is that all this wheeling-and-dealing calls for expert guidance all the way down the line. Right at the start, you need legal

When setting up a full-scale studio, necessary for a shot like this, be sure to check the zoning laws.

advice and a written agreement that defines the rights and obligations of each partner. And you'll need an expert tax accountant or attorney to make the tax benefits work.

Corporation. Legally, a corporation is an artificial person. It can keep or distribute its income as it sees fit, and it's liable for its own debts and taxes.

And psychologically, having a corporate seal gives the average citizen a feeling of being in a much better financial position. And with some reason. Aren't federal tax laws designed to give corporations big breaks? Certainly. And if a corporation goes broke, aren't you, as the president-director-major shareholder-employee, protected from personal loss? Yes, almost always. And can't you and your accountant adjust your take-home pay in a way that allows you and the corporation to retain the maximum number of dollars? Yes. All that and more.

But it is also true that the advantages of incorporation start working for you only after your income becomes substantial. The drawbacks, on the other hand, show up immediately—just when you need all the time, energy and capital you can muster to get your business off the ground and rolling.

Firstly, the initial cost of incorporating is not to be sneezed at. For a comparable amount you might be able to buy yourself a Hasselblad.

Secondly, corporate tax benefits are not automatic. In fact, corporate tax rates in your state may be higher than the rates for individuals. Furthermore, it takes real expertise to get those potential benefits out of the corporate tax laws. Actually, it takes expertise even to read and decipher the instructions and forms that come in the IRS package for corporations.

Thirdly, taxes aside, corporate paperwork can be formidable. Under the laws of most states, you have to draft and file carefully worded Articles of Incorporation and by-laws; elect directors and officers, and issue stock; hold regular meetings of directors and shareholders, and keep formal minutes of all meetings. Then you must present annual packages of paperwork to the state agency that governs and monitors corporations.

In short, incorporation may be a smart and profitable move to make later on. But at the beginning its added costs and complexities can be seldom justified.

GOING FOR THE TAX BREAKS

Our economy is based on the idea that prosperity comes from business growth. That's why most tax breaks go not to individual taxpayers but to businesses. And they go not just to big business, but to small businesses as well, even a small, home-based sole proprietorship.

For example, as an employee, you have to commute to your job. But the costs of transportation aren't deductible from your income tax. Yet as the owner of a home-based photography business, your transportation costs to shooting locations, to prospective clients, and to stores where you buy supplies, are all considered deductible business expenses.

As a hobbyist the money you spend on photographic supplies and equip-

ment isn't deductible. As a professional, all costs for materials and equipment for which you were not reimbursed are either deductible outright or depreciable—that is, costs that can be written off over a period of years. In fact, if the equipment you buy is new rather than used, the tax laws give you not only a depreciation allowance but also an additional tax credit.

As a homeowner you can deduct the interest on your mortgage. But you cannot write off the initial cost of your home, nor can you deduct expenses for such items as utilities and repairs. As a home-based business owner, however, you can deduct a portion of the operating costs. And you can also write off a portion of the initial cost of your home every year. Or if you rent your home, you can deduct a portion of the rent.

As a parent you may pay your kids an allowance to do chores around the house. This cost is not deductible. As a business owner, you can pay them to run errands for your business, and may claim that cost as a deduction.

And that's just for starters. When you start adding it up (or subtracting it down) it's not hard to see why some very successful businesses manage to pay little or no income tax year after year.

But there is one condition to claiming deductions. In order to deduct your business expenses, you have to keep complete, accurate records of them from day one. And in a home-based business especially, where your business activities and expenses tend to mix and merge with your non-deductible personal activities, it's important to set up a system that will make record-keeping automatic and easy.

Since record-keeping is strongly connected to taxes, you should immediately make yourself familiar with the tax form that applies to your business. If you operate as a "sole proprietor" (and you probably will) this will be Schedule C-1040, headed *Profit (or Loss) from Business or Profession, Sole Proprietorship*. Ask the local office of the IRS to send you a copy. And while you're at it, ask for a free copy of the IRS publication called *Business Use of Your Home*. It tells you exactly how to calculate the deductions that apply in a home-based business.

As you'll see, Part II of Schedule C lists *Deductions* in a number of different categories. That list should become an immediate part of your record-keeping system. Knowing what's deductible alerts you in advance to the expenses you must keep track of.

At an office-supply store, buy a ledger and some sheets of ledger paper, the type with many separate ruled columns for entering different kinds of expenses. At the top of each column, write in one of the categories on the Schedule C *Deductions* list. To those add the categories that specifically apply to your business, such as *Film and Processing, Props*, etc.

Set up a separate checking account for your business, and get a credit card that you'll use only for business activities and expenses. With or without a separate account, pay for your deductible expense items by check whenever possible, noting what each· check was for on the stub. Or use your charge card,

and keep the receipt slips that come with the statement. Whenever possible, set up billing accounts with suppliers: it's easier to keep track of monthly billings than a drawerful of individual receipts.

Keep a mileage notebook in your car, and jot down the odometer readings before and after you take runs connected with your business. The mileage is deductible at a standard rate set by the IRS.

Once a year, before tax-time, put it all together. Go through your check-stubs, charge-card itemizations, mileage notes, and other records. Enter the numbers in the appropriate columns on your ledger sheets, and add up the numbers in the columns. You're then ready to deal with Schedule C.

But keep in mind that this easy (and somewhat primitive) record-keeping system is only the beginning. If you do your own tax work yourself, you'll gradually need to learn and use the more sophisticated tax benefits available to business. If not, you'll find out about them from a good tax accountant.

INSURANCE
Yes, you'll need insurance, and probably in several categories.

Fire, theft, and vandalism. A homeowner's (or renter's) policy covers fire, theft, and vandalism risks connected with your home and personal possessions, and usually covers liability for injuries to people who come to your home. When you're using part of your residence for business, you must notify your insurer. In some cases your business equipment will have to be insured

under a separate commercial policy.

Rider: For coverage on your camera and other expensive equipment when you're away from home, you need a floater or "rider" that attaches to your household policy. Floaters cover only the specific equipment identified in the policy; so you should update your coverage list at least once a year or when you make substantial additions to extend it to new purchases.

General liability and valuable papers insurance. A *General-liability* policy covers you for such accidents as a child tripping over a tripod or a light falling on an assistant. It is definitely worth having.

When you move into a separate studio, a standard business-insurance policy will protect you against the usual risks. Because your business records and negative files are so important, you may also want to invest in *valuable papers* coverage.

EXTENDING CREDIT
As a consumer you know that you often buy more and pay more when you can charge purchases on a credit card. Your private clients will follow the same pattern: when they can charge what they owe you on a credit card, your sales will rise. Besides which, you get your money immediately, without having to bill and collect.

To get the system rolling, set up your business account at a bank that handles MasterCard and Visa. Then to handle your credit-card sales, you merely "deposit" the card sales-slips in your business account. The bank deducts its handling fee (usually four to six percent of

the purchase) and credits the rest to your account.

On the other hand, when working on editorial and advertising assignments, you may find yourself extending credit against your will. In most such transactions you'll be expected to bill the client for your services. When the bill isn't paid for weeks or months, you are in effect financing your client. For this reason many photographers include a line on their invoice forms that says something like: "Service charge of 1 percent per month on statements not paid within 30 days." It doesn't always help, but it couldn't hurt.

GETTING CREDIT . . .
When you need credit, you will probably turn to your friendly banker. And you will probably find that even the friendliest bankers aren't all that friendly when it comes to making loans to photographers, especially beginners.

However, once you're established, can show healthy profit statements and projections, and need credit for equipment or expansion, you may find loan officers considerably more amenable. Under those circumstances it helps to know the different kinds of business loans available from banks, so you can decide which best meets your needs:
• A *line of credit* is an open-ended arrangement in which the bank will provide short-term credit up to a stipulated maximum. When you can qualify, it's a convenient way to be assured of credit in advance of need.
• A *short-term loan* has to be repaid in a year or less. However, when a loan is written for, say, three months, it's not uncommon for the borrower to pay just the interest and then, when the loan comes due, renew it for another three months.
• An *intermediate-term loan* can be used for operating capital or expansion. But you must provide security (or collateral) against default. Security can be anything from equipment, real estate, or accounts receivable to securities or life-insurance policies.
• *Long term loans* usually aren't available from banks except for financing real estate.

If you can't qualify for a bank loan, don't overlook other possibilities for financial help. For example, the federal government offers business loans through a number of agencies, including the Small Business Administration (SBA), the Veterans Administration, and the Economic Development Administration. Many state and local governments also offer business-development loans. You may even qualify for a public or private grant. For a revealing look at the possibilities of getting money for photographic projects, read *Grants in Photography—How to Get Them* by Lida Moser (Amphoto, New York, 1978).

GETTING ADVICE AND HELP
One of the most reliable buddies available to business beginners is the Small Business Administration. In addition to being a possible source of loan money, it publishes a wide range of how-to-do-it business booklets and pamphlets; most of them are free, the rest are sold at cost, and some of them are listed in the *Appendix*.

When you become a professional, your unreimbursed costs for supplies and equipment are deductible or depreciable.

In addition to all that, the Small Business Administration maintains regional offices throughout the United States, where its advisors will give you free and expert counseling on just about any business problem you're likely to face, from inventory control to bidding on government contracts. To locate the nearest office, look under United States Government in the white pages of your phone directory or call the federal-information number in your area.

Still another fine service that operates through the Small Business Administration is SCORE. The letters stand for Service Corps of Retired Executives, and the service is staffed by retired professionals who will come to your place of business and give you one-to-one, on-the-spot advice on your own specific problems . . . free of charge. And beyond that, SBA, SCORE, and many community colleges sponsor free or low-cost management seminars and workshops where you can meet and exchange ideas with other business and professional people who are walking in moccasins much like your own.

And finally, tackle your business chores with confidence. After all, anyone who can handle children should have no trouble at all with the nuts-and-bolts of management. In fact, at both ends of the business there's a single formula for success: Tune in, take charge . . . and stay in control.

Appendix

SUPPLIERS

If businesses in your area cannot provide the equipment, services, and supplies you need, the following firms may be able to help you by mail:

Equipment

California Camera
8702 Wilshire Blvd.
Beverly Hills, CA 90211
(213) 855–1555
Good general source for equipment.

Camera City
12236 West Pico Blvd.
Los Angeles, CA 90064
(213) 477–8833
Good general source for equipment.

Flash Clinic
156 Fifth Ave.
New York, NY 10010
(212) 673–4030
All flash equipment, view cameras, Calumet equipment.

Helix Camera
325 West Huron St.
Chicago, IL 60610
(312) 944–4400
Good source for Hasselblad equipment.

Lens & Repro
33 West 17th St.
New York, NY 10011
(212) 675–1900
Large selection of used and new equipment; they'll ship C.O.D.

Photo Care
170 Fifth Ave.
New York, NY 10010
(212) 741–2990
Strobes, 35mm, 2¼-square, and view cameras. Call with your equipment order; they'll ship C.O.D. or on receipt of a certified check.

Film and Processing

Color Perfect
200 Park Ave. South
New York, NY 10003
(212) 777–1210

K&S Photographics
180 North Wabash
Chicago, IL 60601
(312) 782–0522
1155 Hanley Industrial Court
St. Louis, MO
(314) 962–7050

Modernage Photographic Services
1150 Ave. of the Americas
New York, NY 10036
(212) 997-1800

P.E.C. Laser Color Laboratories
Fairfield Drive
West Palm Beach, FL 33407
(305) 848–7211
Handles only 35mm chromes; provides exceptionally good, special laser print. Fast service, good prices; be sure to ask for their professional price list.

Photo Image
1117 North Formosa
Los Angeles, CA 90046
(213) 851–0334

The Color Place
135 Parkhouse St.
Dallas, TX 75207
(214) 651–8725
2931 Morton St.
Fort Worth, TX 76107
(817) 335–3515
4201 San Felipe
Houston, TX 77027
(713) 629–7080
When shipping film for processing, wrap film cans and stuff box with crumpled newspaper. Mark the outside of the package: Film—Handle With Care—Do Not X-Ray.

MARKETING DIRECTORIES

The directories listed below will help you find stock-photo buyers and potential clients for editorial and advertising assignments. Most of these directories are available at the business-reference sections of public libraries. Generally they can be looked at on the premises but cannot be checked out. You can also order them from their publishers. For information on current prices, ask your bookseller or contact the publishers directly.

Audio-Visual Market Place
R.R. Bowker
1180 Avenue of the Americas
New York, NY 10036
Lists production companies and other firms that buy and assign motion picture or still photography for audiovisual use.

Business Publications
Standard Rate & Data Service
5201 Old Orchard Road
Skokie, IL 60077
Lists thousands of business and trade publications; categorized by subjects covered.

Gebbie Press All-In-One Directory
Gebbie Press
Box 1000
New Paltz, NY 12561
Lists more than 7,500 consumer and trade publications; categorized by subjects.

Gift and Decorative Accessory Buyers Directory
Geyer-McAllister Publications
51 Madison Ave.
New York, NY 10010
Lists firms that buy stock photos for such commercial uses as calendars, greeting cards, and posters.

Interior Design Buyers Guide
Interior Design Magazine
850 Third Ave.
New York, NY 10022
Lists firms that publish photomurals, fine prints, and graphics for decorative use.

L.A. Work Book
Alexis Scott
6140 Lindenhurst Ave.
Los Angeles, CA 90048
Lists magazine and ad agency art directors
in the L.A. area; also local photo reps, styl-
ists, and makeup specialists.

Literary Market Place
R.R. Bowker
1180 Avenue of the Americas
New York, NY 10036
Annual Bible of the publishing industry;
lists publishers and their specialties; in-
cludes some art directors' names.

Mail Order Business Directory
B. Klein Publications
PO Box 8503
Coral Springs, FL 33065
Lists thousands of firms that do business by
mail, most of which are heavy buyers of
product photography.

Photographer's Market
Writer's Digest Books
9933 Alliance Road
Cincinnati, OH 45242
Comprehensive overview listing paying
markets, includes list of stock agents.

Photography Market Place
R.R. Bowker
1180 Avenue of the Americas
New York, NY 10036
Covers stock agents, graphic designers, and
other potential buyers.

Standard Directory
of Advertising Agencies
National Register Publishing Co.
5201 Old Orchard Road
Skokie, IL 60077
Lists major agencies, their clients, and in
some cases their art directors.

The International Buyer's Guide
of the Music-Tape Industry
Billboard Publications
1515 Broadway
New York, NY 10036
Lists thousands of recording companies,
who are potential buyers of album-cover
photography.

PROFESSIONAL ORGANIZATIONS

The organizations below have chapters in
major cities throughout the United States:

The American Society
of Magazine Photographers
205 Lexington Ave.
New York, NY 10016
Provides many services for members; espe-
cially helpful to photographers interested
in advertising or publication clients.

Professional Photographers of America
1090 Executive Way
Des Plaines, IL 60018
Members include portrait and commercial
photographers.

BUSINESS MANAGEMENT AIDS

The helpful and informative booklets listed
below are published by the United States
Small Business Administration, and they're
free for the asking. You can order them by
name and number by writing the Small
Business Administration, PO Box 15434,
Fort Worth, Texas 76119. You may also or-
der them by calling, toll-free, (800)
433–7212 (in Texas only, call (800)
792–8901).

SBB	64	*Photographic Dealers and Studios*
SBB	15	*Record-keeping Systems— Small Store and Service Trade*
SBB	2	*Home Businesses*
SMA	126	*Accounting Services for Small Service Firms*
SMA	130	*Analyze Your Records to Reduce Costs*
SMA	146	*Budgeting in a Small Service Firm*
SMA	155	*Keeping Records in Small Business*
MA	170	*The ABC's of Borrowing*
MA	193	*What is the Best Selling Price?*
MA	220	*Basic Budgets for Profit Planning*
MA	232	*Credit and Collections*
MA	239	*Techniques of Time Management*
MA	246	*Developing New Accounts*

For a complete list of free booklets, ask for
SBA 115A, *Free Management Assistance
Publications*. For a list of business booklets
available at low cost, ask for SBA 115B,
For-Sale Booklets.

PROMOTIONAL MEDIA

Listed below are publications specifically
designed for art directors and others in the
photo-buying business. Many photogra-
phers—especially those trying for top-
money advertising and editorial clients—
buy ads in them. All of them will provide
you with reprints of your ad for promo-
tional mailers or drop-offs. For specific in-
formation on rates and other services:
A.S.M.P. Book
The American Society
of Magazine Photographers, Inc.
205 Lexington Ave.
New York, NY 10016

American Showcase
30 Rockefeller Plaza
Ste. 1929
New York, NY 10020

Art Directors' Index to Photography,
Film & Media Production
John S. Butsch Associates
415 West Superior St.
Chicago, IL 60610

Creative Black Book
Friendly Publications
401 Park Ave. South
New York, NY 10016

Madison Avenue Handbook
Peter Glenn Publications
17 East 48th St.
New York, NY 10017

Index

Edited by Diane Lyon and Micaela Rosenzweig
Designed by Bob Fillie
Graphic Production by Hector Campbell
Set in 11 pt. Laurel